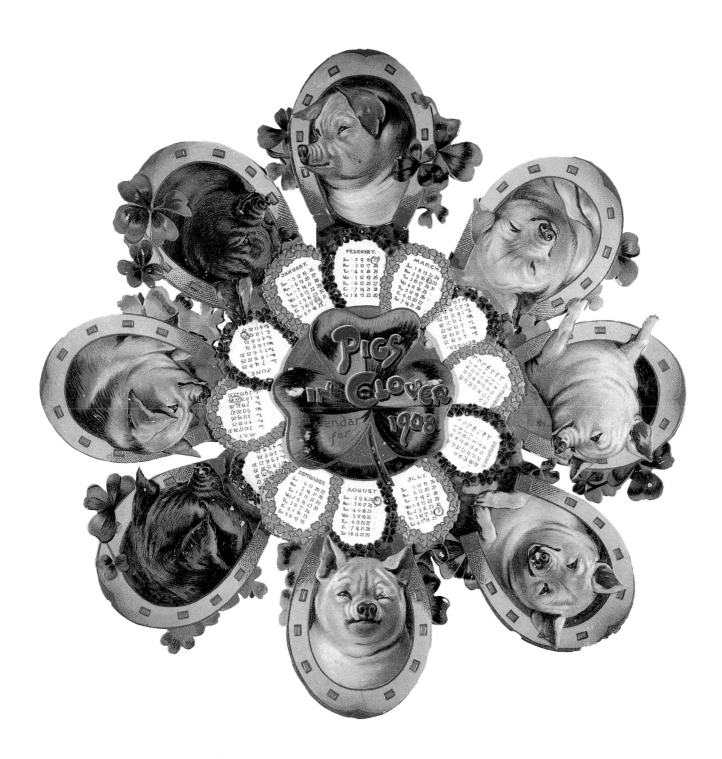

The Ubiquitous Pig

T H E U B I Q U I

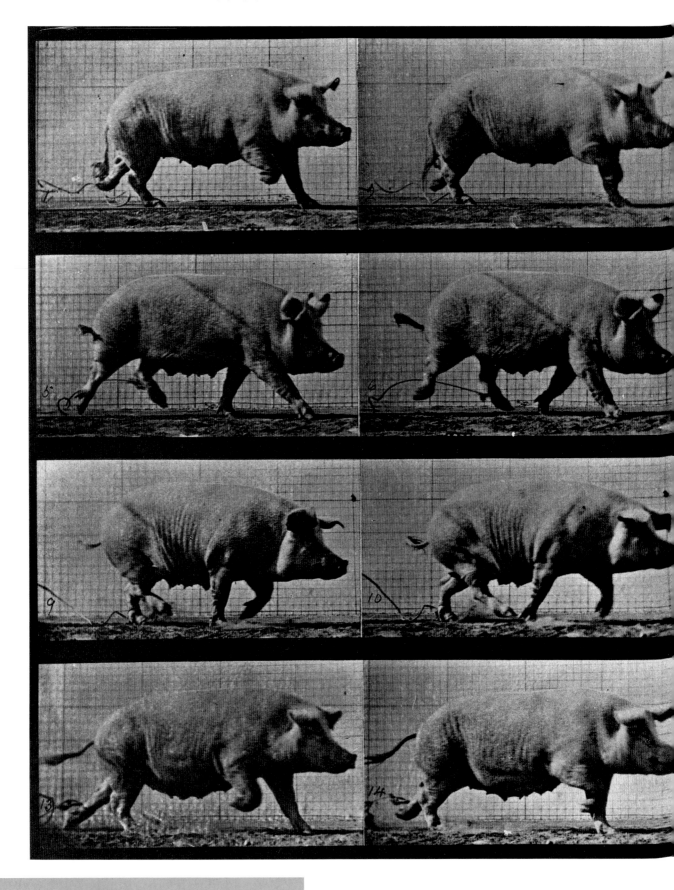

MARILYN NISSENSON AND SUSAN JONAS

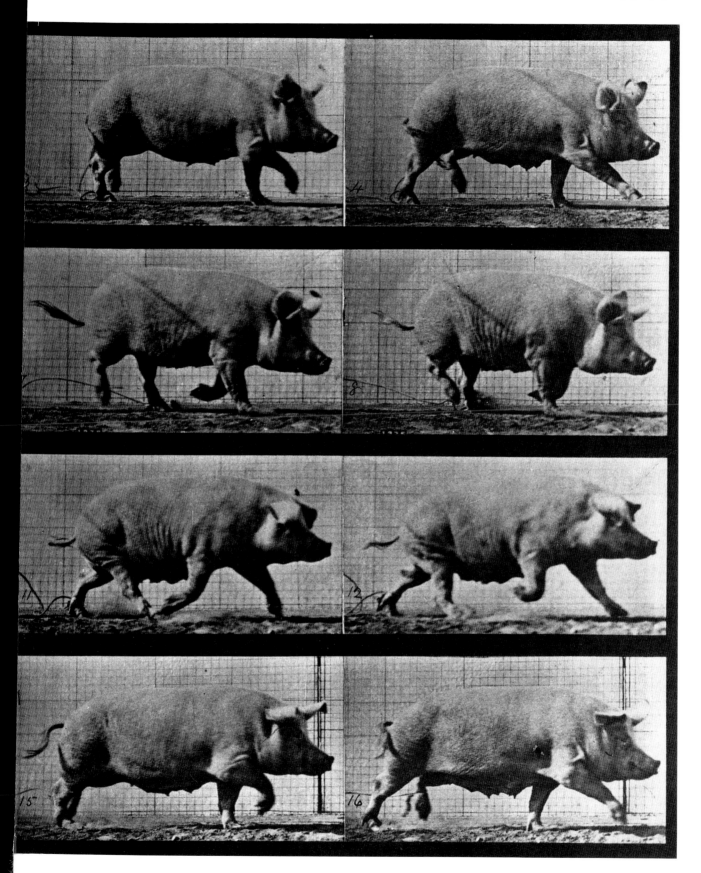

HARRY N. ABRAMS, INC., PUBLISHERS, NEW YORK

Editor: Harriet Whelchel
Designer: Carol Robson

Library of Congress Cataloging-in-Publication Data
Nissenson, Marilyn 1939–
 The ubiquitous pig / Marilyn Nissenson and Susan Jonas.
 p. cm.
 Includes bibliographical references (p. 134) and index.
 ISBN 0-8109-3916-9
 1. Swine—Miscellanea. 2. Swine in art. 3. Swine—Collectibles.
 I. Jonas, Susan. II. Title.
 GT5895.S95N57 1992
 636.4—dc20 92-4549
 CIP

Text credits are cited within the body of the book,
with the following exceptions:

"Animals Are Passing from Our Lives" reprinted from
Not This Pig, © 1966 by Philip Levine. Wesleyan
University Press. By permission of University Press
of New England

The Book of a Naturalist by W. H. Hudson. Reprinted
courtesy of AMS Press, Inc., New York

"The Pig" by Ogden Nash, from *Verses from 1929 On*.
Copyright 1933 by Ogden Nash. First appeared in the
New Yorker. Reprinted by permission of Little, Brown
and Company, Andre Deutsch, and Curtis Brown, Ltd.

"The Pigs and the Charcoal-Burner" by Walter de la
Mare. By permission of The Literary Trustees of
Walter de la Mare and The Society of Authors as
their representative

Under Milk Wood by Dylan Thomas. Copyright 1954.
New Directions Publishing Corporation. Reprinted by
permission of New Directions and J. M. Dent Ltd.

Published in 1992 by Harry N. Abrams, Incorporated, New York
A Times Mirror Company

Printed and bound in Italy

Page 1:
Pigs in Clover. 1908. Mechanical
trade card. Collection Frances
Converse Massey

Pages 2–3:
Eadweard Muybridge (Anglo-
American). *Sow Trotting. One
Stride in 13 Phases*. Plate no. 675
from *Animal Locomotion: An
Electro-photographic Investigation of
Consecutive Phases of Animal Move-
ments*. Philadelphia, University
of Pennsylvania, 1887. Depart-
ment of Special Collections,
Stanford University Libraries

Page 134:

Molly Nye Tobey (American).
Indiana. Hooked rug: wool fabric
strips on burlap ground,
35½ × 53". Shelburne Museum,
Vermont. Gift of Joel, Jonathan,
and Joshua Tobey, 1989

*In 1942 Mrs. Tobey, an American
craft artist, began a project that
would take nearly two decades to
complete. She designed and made a
hooked rug representing the his-
tory, industry, natural resources,
and heritage of each of the fifty
states. Because the basis of Indiana
agriculture is corn and livestock,
Mrs. Tobey chose to characterize
the state with this cheerful hog.*

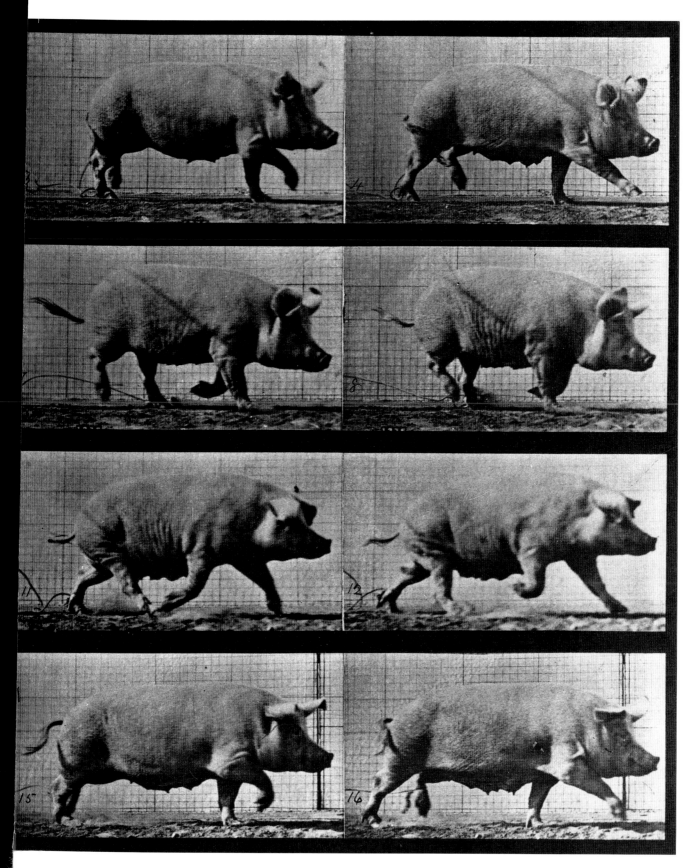

HARRY N. ABRAMS, INC., PUBLISHERS, NEW YORK

Editor: Harriet Whelchel
Designer: Carol Robson

Library of Congress Cataloging-in-Publication Data
Nissenson, Marilyn 1939–
 The ubiquitous pig / Marilyn Nissenson and Susan Jonas.
 p. cm.
 Includes bibliographical references (p. 134) and index.
 ISBN 0–8109–3916–9
 1. Swine—Miscellanea. 2. Swine in art. 3. Swine—Collectibles.
 I. Jonas, Susan. II. Title.
 GT5895.S95N57 1992
 636.4—dc20 92–4549
 CIP

Text credits are cited within the body of the book,
with the following exceptions:

"Animals Are Passing from Our Lives" reprinted from
Not This Pig, © 1966 by Philip Levine. Wesleyan
University Press. By permission of University Press
of New England

The Book of a Naturalist by W. H. Hudson. Reprinted
courtesy of AMS Press, Inc., New York

"The Pig" by Ogden Nash, from *Verses from 1929 On*.
Copyright 1933 by Ogden Nash. First appeared in the
New Yorker. Reprinted by permission of Little, Brown
and Company, Andre Deutsch, and Curtis Brown, Ltd.

"The Pigs and the Charcoal-Burner" by Walter de la
Mare. By permission of The Literary Trustees of
Walter de la Mare and The Society of Authors as
their representative

Under Milk Wood by Dylan Thomas. Copyright 1954.
New Directions Publishing Corporation. Reprinted by
permission of New Directions and J. M. Dent Ltd.

Published in 1992 by Harry N. Abrams, Incorporated, New York
A Times Mirror Company

Printed and bound in Italy

Page 1:
Pigs in Clover. 1908. Mechanical
trade card. Collection Frances
Converse Massey

Pages 2–3:
Eadweard Muybridge (Anglo-
American). *Sow Trotting. One
Stride in 13 Phases*. Plate no. 675
from *Animal Locomotion: An
Electro-photographic Investigation of
Consecutive Phases of Animal Move-
ments*. Philadelphia, University
of Pennsylvania, 1887. Depart-
ment of Special Collections,
Stanford University Libraries

Page 134:

Molly Nye Tobey (American).
Indiana. Hooked rug: wool fabric
strips on burlap ground,
35½ × 53". Shelburne Museum,
Vermont. Gift of Joel, Jonathan,
and Joshua Tobey, 1989

*In 1942 Mrs. Tobey, an American
craft artist, began a project that
would take nearly two decades to
complete. She designed and made a
hooked rug representing the his-
tory, industry, natural resources,
and heritage of each of the fifty
states. Because the basis of Indiana
agriculture is corn and livestock,
Mrs. Tobey chose to characterize
the state with this cheerful hog.*

INTRODUCTION

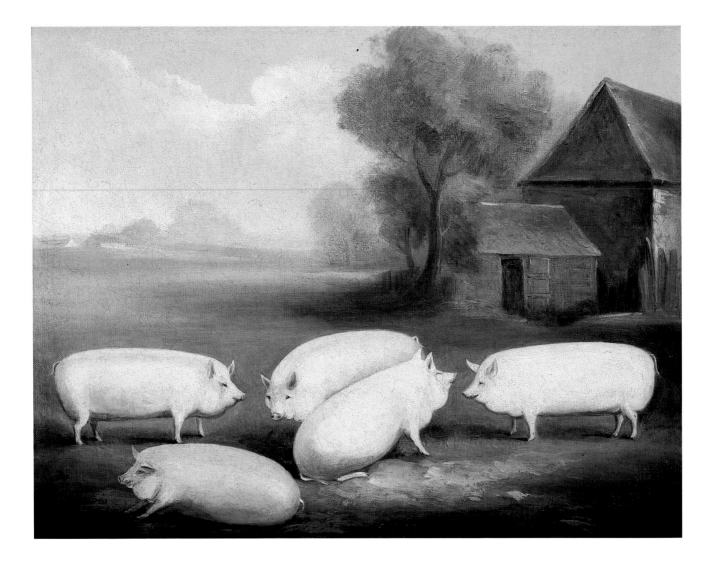

W. H. Davis (English). *Five Prize Pigs*. 1855. Oil on canvas, 14 × 18″. Courtesy Iona Antiques, London

PIG SHOW

The Head-Piece.

The Head-Piece. Illustration from *The Headlong Career and Woful [sic] Ending of the Precocious Piggy,* by Thomas Hood. Illustrated by his Son. Boston, M. A. Mayhew, 1860. Collection Frances Converse Massey

Theresa, a well-muscled, 235-pound spotted Poland China hog, bursts into the show ring in Barn 4 at the Sussex County Farm and Horse Show. She bucks like a bronco, dashes around the ring, and slides on her knees in the dirt. Sugar Magnolia, a comely Yorkshire female, about the same size, follows, bounding and bucking on her tiny pink feet. She too slips and slides; the audience laughs. The pigs calm down and root in the black dirt.

"Good afternoon, folks, and welcome to the Open Swine Show," announces the master of ceremonies, Bill Hubbard, of Hubbard Hill Farm, Sussex County, New Jersey. "We're holding our competition right here in the pig barn, and not in the Blue Barn, where the cattle and sheep are judged, because it's not easy to move pigs. You can't put a halter on them and walk them around. They're too stubborn. We like to keep them in their own pens up until the last minute so we can get them in and out of the ring fast."

The animals being judged are five and a half to six months old and weigh 225 to 240 pounds. The teenage swineherds are members of the local 4-H Club—the Sussex Squealers. They carry short crooks to keep their animals moving and brushes for last-minute grooming.

Suddenly, with no apparent provocation, Sugar Magnolia rushes toward Pippi, another pink Yorkshire, and nips her behind the right ear. Pippi bites Magnolia on the snout; they lock in a clinch. The herdsmen break it up, shoving the two pigs to opposite sides of the ring with heavy boards.

"You'll see some action in this pen, ladies and gentlemen," says Hubbard. "The pigs will go after each other. It's hot, and the competition makes them tense. But we haven't lost a herdsman yet."

The judge for the day's events is Dave Hoffman, a county agent for the Pennsylvania Department of Agriculture Extension Service. Mr. Hoffman is evaluating gilts—young females—for their breeding potential. He likes to see a pig who is wide in the chest and rump, evidence that she can carry a litter easily. She must be well muscled and not too fat—so she will pass on genes for lean meat. He checks her undercarriage to see if her nipples are accessible and if she has

enough of them to nurture a big litter. Sugar Magnolia, despite the gash on her snout, wins the blue ribbon over eighteen other contestants.

Next Mr. Hoffman supervises a competition of market-ready hogs—males and females who weigh between 225 and 250 pounds. While he examines the contestants, the announcer tells the crowd, "Big fat sloppy hogs aren't popular anymore. These pigs have been fed nothing but corn and soybeans. No swill, no garbage. No chemicals, no hormones." Mr. Hoffman looks for heavy muscles that will make good loin and shoulder roasts. He awards Pony Boy a prize for being "very expressive in the ham area."

PIG INTELLIGENCE

Bill Hubbard describes the smartest pig he ever saw. "He was a fifty-pound piglet we were bringing back to the farm on a truck. This little guy jumped off, and we chased him through the state park next to our farm for three days. Just when we thought we had him cornered, he'd get away. In the end his stomach got the better of him, and he was smart enough to find his way home."

Mr. Hubbard's wife, Cordelia, interrupts. "I'll never forget the time the pigs got out. Our neighbor called to say that our pigs had rooted up her lawn. But when we checked the pen, there they were, sound asleep. A little later, when our son, Adam, went up to the barn, he discovered the cartons of M & M's that the 4-H kids were going to sell had been totally destroyed; sixty boxes were in shreds, and there wasn't a piece of chocolate left. Somehow those pigs had gotten out of the pen, torn up the neighbor's yard, found the candy, and eaten their fill. Then, like three-year-olds hoping not to get caught, they managed to get themselves back into the pen. To this day, I don't know how they pushed open the lock to get out or to get back in."

Mr. Hubbard interrupts, "All pigs are pretty smart. They know how to operate an automatic feeding system. We put the grain in bins, and they lift the latch to get at their food. Cows could never figure that out; they'd starve. Horses would never stop; they'd eat themselves to death. The pigs take just what they need. They're so smart they'd be ruling the place if there weren't people around—like in that book, *Animal Farm*."

George Orwell's political parable *Animal Farm* describes the natural hierarchy that evolves when animals take matters into their own hands: "The work of teaching and organizing the others naturally fell to the pigs, who were generally recognized as being the cleverest of animals."

A five-year research program at the University of Kentucky confirmed that pigs are the most intelligent of all farm animals. They also outperform dogs. Pigs have been taught to retrieve, to race in competition, to dance, to pull a cart, to heel, and to scent land mines. They can be easily housebroken. Pigs are very curious. Ronald Harrison, a pig farmer from Tipton, Pennsylvania, once told a reporter from *The New Yorker*, "A pig doesn't take anything for granted. He has to check everything out. Smell it, push at it, see what it does. With a pig, you show him something one time and that's it—he's got it."

PIG LATIN

In his 1946 address to the Modern Language Association, "Otesnay Onnay Igpay Atinlay: The History and Analysis of Pig Latin," Allen Walker Read cited the earliest account of a secret language, which actually *was* a form of Latin. Professor Read revealed that as early as 1593, Giovanni della Porta reported a language with transposed syllables spoken in his native Italy. In *De Furtivus Literarum Notis* (Concerning Secret Writing), Della Porta advised, "If you wish to say *Hostis Adest Cave Tibi* (an enemy is here, watch out for yourself), you might say *Stisho Estad Veca Biti.*"

"Amscray!"

Schoolchildren in many nations have devised and preserved secret languages in classic forms. In 1964 Glen Pound, an American scholar of linguistics, identified 119 contemporary variations from thirty-seven countries in the Western Hemisphere, Europe, the Middle East, Africa, the Indian subcontinent, and Asia. Children speaking pig Latin usually transpose consonants or syllables, making the first last or vice versa and sometimes inserting an additional nonsense syllable, as Dr. Read points out, "just to trip you up."

The first mention of pig Latin in English dates from 1641; the origin of the term is obscure. It was spoken among English schoolboys and criminals in the mid-nineteenth century; a version used at Winchester was called Hypernese. One former student remembers that his first impression on hearing Hypernese was "contempt for all schoolmasters, who kept boys shut up for hours studying Latin and Greek, when here was quite as good a language as either, and anybody could learn it in five minutes."

Children speak pig Latin to exclude grown-ups or other children. Some linguists think that it—like all secret language—is an exercise in arbitary linguistic mastery. Dr. Pound discovered that it is "learned quite readily at an early age, that poor readers have the most difficulty, and the group as a whole will follow the lead of the first speakers with respect to the selection of initial consonant cluster over invariable initial consonant in performing pig Latin rearrangements."

No one knows what all this has to do with pigs.

Clockwork mechanical toy. Manufactured by Deschamps. French. 1890–1900. Pigskin on cardboard frame. Collection Vernon E. Chamberlain

When wound, the pig is quite animated. His four limbs move separately, his head bobs up and down, and his tail moves from side to side. The pig also squeals.

PETS

Among the world's domesticated animals, only dogs outnumber pigs. Pig lovers have long thought it unfair that dogs are called "man's best friend"; they know that pigs are equally willing to be loyal, affectionate, and bring slippers at the end of the day. In "The Uses of Diversity," G. K. Chesterton suggested that pigs should be liberated from the sty and brought into the parlor:

> *We do not know what fascinating variations might happen in the pig if once the pig were a pet. . . . You know a Dachshund in the street; you know a St. Bernard in the street. But if you saw a Dog in the street you would run from him screaming. For hundreds, if not thousands, of years*

no one has looked at the horrible hairy original thing called Dog. Why, then, should we be hopeless about the substantial and satisfying thing called Pig? Types of Pig may be differentiated; . . . There may be little, frisky, fighting pigs like Irish or Scotch terriers; there may be little pathetic pigs like King Charles spaniels. . . . Those interested in hair-dressing might amuse themselves by arranging the bristles like those of a poodle. . . . With elaborate training one might have a sheep-pig instead of a sheep-dog, a lap-pig instead of a lap-dog.

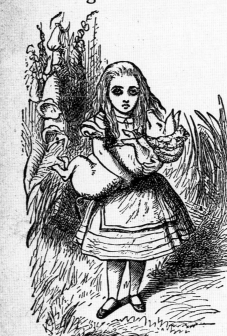

Alice was just beginning to think to herself, ' Now, what am I to do with this creature when I get it home ? " when it grunted again, so violently, that she looked down into its face in some alarm. This time there could be *no* mistake about it: it was neither more nor less than a pig, and she felt that it would be quite absurd for her to carry it any further.

So she set the little creature down, and felt quite relieved to see it trot away quietly into the wood. " If it had grown up," she said to herself, " it would have been a dreadfully ugly child: but it makes rather a handsome pig, I think." And she began thinking over other children she knew, who

Sir John Tenniel. Illustration from *Alice's Adventures in Wonderland*, by Charles Dodgson (Lewis Carroll). London, Macmillan, 1866. General Research Division, The New York Public Library. Astor, Lenox and Tilden Foundations

11

Chesterton would have loved minipigs. Minipigs are diminutive breeds from Asia and the Yucatán that are the right size for house pets. When full-grown, they stand about one and a half feet tall and weigh anywhere from seventy to one hundred and fifty pounds, about one-tenth the size of a full-grown Hampshire or Duroc pig. In 1991 about ten thousand American households sheltered a pet minipig, and demand exceeded supply.

Minipigs can be housebroken faster than most dogs. They are delighted to join the family at the dinner table and to cuddle in their master's bed. Yucatán minis were bred to be hairless, making them the Chihuahuas of swinedom, and reducing the risk of fleas. Fideau, a Yucatán mini, lived in Rutherford, New Jersey, before retiring to a farm in upstate New York. In his suburban community, Fideau walked on a leash and loved to ride in the car. Fideau was a bit of a ham; he could kneel, sit up, beg, and pick which fist his cookie was in. His master told a reporter for the *New York Times*, "I'm not saying he's not a pig, but he's a nice clean pig." The owner admitted that while Fideau was fond of people, his primary passion seemed to be food. "All pigs care about is eating," he said. Fideau played with children in the neighborhood, who loved to feed him biscuits. Man and pig shared a bedroom. "It's not bad," the owner told the *Times*. "He sleeps through the night. But as soon as my alarm goes off in the morning, it's oink, oink."

Louis, a pet minipig who lives near San Francisco, has a passion for chilled juice bars; he figured out how to open the refrigerator and serve himself. One day his owner came home to find the refrigerator open and Louis inside the food compartment, polishing off its entire contents. The pig had to be pulled out by his hind legs. Soon after, the owner installed a special latch beyond the pig's reach at the top of the refrigerator door.

Like their big cousins, miniature pigs have no sweat glands. They prefer to cool themselves by dunking in water, but they will roll in mud if that is all that is available. They are dedicated rooters. They persistently poke at carpets and can tear up a suburban lawn as fast as a Rototiller.

Several pig owners report that their pets like to watch television with the family and seem to have favorite programs. Other pigs like the buzzing sound of telephones; one owner says she sometimes comes home to find her phone off the hook and her pig looking guilty.

PIG FACTS

Pigs belong to the family Suidae, in which there are five genera: bush pigs, warthogs, barbirusa, giant forest pigs, and wild boars. They are the most ancient of the nonruminant mammals: like humans and unlike cattle, they chew and swallow their food once. They are even-toed ungulates, but unlike most other of these hoofed mammals, they are omnivorous rather than exclusively plant-eating. Wild boars *(Sus scrofa)*, of which domestic pigs are a subspecies, are the most widely distributed Suidae. Domestic pigs *(Sus scrofa domesticus)* can breed with wild boars, and if left untended they will revert to a feral state.

Proto-pigs roamed the forests and wetlands of Europe forty million years ago; their fossils have been found in Europe and Asia but not the Western Hemisphere. The native American peccary, a grizzled nocturnal beast that looks somewhat like a wild boar, is a separate species related to the ruminants.

Wild pigs are now found on every continent; they were introduced to the Western Hemisphere and Australia during the voyages of discovery. Christopher Columbus took eight hogs along on his second voyage in 1493 and released them on the island of Hispaniola to ensure a food supply for the colony he was trying to establish there. Pigs accompanied Hernando Cortés to the Central American mainland in 1527. Hernando de Soto introduced thirteen hogs to North America when he landed in Tampa Bay in 1539, and native North Americans soon acquired a taste for their flesh.

An account of De Soto's expedition appeared in 1557. It describes a series of incidents that took place during the winter of 1540–41, in the territory of the Chickasaw, on the west bank of the Yazoo River in what is now the northern part of Mississippi:

> *The Governor invited the caciques and some chiefs to dine with him, giving them pork to eat, which they so relished, although not used to it, that every night Indians would come up to some house where the hogs slept, a crossbow shot off from the camp, to kill and carry away what they could of them.*

De Soto ordered that poachers be shot on sight. When three Indians were caught in a botched pig-napping, he had two of them

executed and sent the third back to the tribe with his hands cut off. Despite the pork-related Indian attacks noted in the record of De Soto's expedition and the hunger of his own men, De Soto's herd grew to seven hundred head within three years. Their feral descendants became known as the American wild boar or razorback.

Purebred pigs were developed during the eighteenth and nineteenth centuries as farmers sought to maximize various traits such as temperament, hardiness, fast growth, reproductive capacity, and mothering skills. While about three hundred different breeds are recognized around the world, most American pigs today belong to one of eight breeds: Berkshire, Hampshire, Duroc, Poland China, Spot, Landrace, Yorkshire, and Chester White.

In the wild some pigs mate year round; others produce one litter a year. Farmers like their domestic sows to produce eight to ten piglets in each litter—after a gestation period of three months, three weeks, and three days—and they usually farrow two litters a year. Piglets are weaned at twenty-eight days, when they weigh about thirty to thirty-five pounds.

In American farm terminology, a pig of either sex becomes a hog when it reaches one hundred pounds. A young male is called a shoat, and a female who has not yet produced a litter is known as a gilt. Boars are breeding males, and sows are the females with whom they have produced offspring.

Growing pigs consume five to six pounds of feed a day, and they are very efficient eaters. Hogs turn three pounds of grain in their feeding trough into a pound of weight gain, whereas cows and sheep have to eat nearly ten pounds of fodder to put on a pound. Compared to other livestock, pigs have small stomachs relative to their size and need to eat frequently. Under normal circumstances, they will not overeat. They are particular about their diet; in one study, a group of hogs rejected 171 out of 200 different vegetables offered to them.

Left alone, domestic pigs would live twelve to fifteen years and weigh more than a thousand pounds. The largest pig ever recorded was Big Bill, a Poland China hog owned by W. C. Chappell of Jackson, Tennessee, in 1933. Bill weighed in at 2,552 pounds and measured nine feet from snout to tail.

Each year nearly 650 million pigs worldwide are raised to be turned into 66 million tons of pork. Americans routinely eat more than 16 billion pounds of bacon, ham, and fresh, canned, and preserved pork

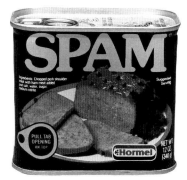

Spam luncheon meat—a mixture of spiced pork shoulder and ham—was introduced in 1937 by the Geo. A. Hormel Co. as "the Miracle Meat." Since then, Hormel has sold more than 4 billion cans. In 1942 Edward R. Murrow reported, "This is London. Although the Christmas table will not be lavish, there will be Spam for everyone." During World War II 100 million pounds of Spam fed American and Allied soldiers, who weren't always grateful; Spam was derided by GI's as "ham that didn't pass its physical." Today more than 140 million cans of Spam are sold worldwide each year, and an estimated 60 million Americans eat it regularly. Hormel asserts that the shelf life of the product is "indefinite."

After the Revolution, American farmers began to move West, taking their pigs with them. As western herds grew, commercial slaughterhouses and packing plants in many Ohio cities processed the meat for the growing urban markets back East. Cincinnati, the leading pork-packing center in the country in the mid-1800s, was known as Porkopolis.

View of Cincinnati.—[Perfectly accurate.]

annually. From the late 1880s until the late 1940s, Americans routinely ate fried food and cooked with lard. In both World Wars, pork was the basic component of high-caloric C and K rations, and lard was used in the manufacture of explosives. Farmers used to breed for fat, but consumer worries about cholesterol and weight have led to a recent redesign of the pig: Selective breeding and a revised diet have produced pigs that are 50 percent leaner than those raised in the 1960s.

The phrase "high on the hog," which describes a person with extravagant tastes, is said to reflect the nineteenth-century British army practice of serving enlisted men meat from pig legs—the shoulder and ham cuts. Officers ate the more tender meat from the loin, which was "higher on the hog."

After meat, medical uses rank second in the commercial value of pigs, followed by pigskin for leather goods, and bristles for fine brushes. Hogs are a source of many drugs—among them insulin and other hormones—that are used in the treatment of human diseases. Genetically engineered pigs produce a component of human blood

that replaces transfusions from human donors and may soon become a primary source of organs to be transplanted into human patients.

Man and swine are surprisingly similar physiologically. Pigskin is used in human skin grafts. Pigs' heart valves are superior to synthetic ones as replacement implants for people with cardiac disease. Because pigs will drink hard liquor voluntarily, they have been used in studies of alcoholism. Some test animals have cooperated by drinking a quart of vodka per day. All of this led one professor of animal husbandry to say, "Man is more nearly like the pig than the pig wants to admit."

ROAST PORK

The Chinese were the first to domesticate the pig, some five thousand to seven thousand years ago, and, according to legend, they were the first to savor its tender flesh. In *A Dissertation upon Roast Pig*, Charles Lamb tells the story of Bo-bo, the son of a swineherd, who accidentally burned down his father's house with a litter of nine newborn piglets inside. When Bo-bo stooped down to touch one of the charred bodies, hoping it might still be alive,

> *he burnt his fingers, and to cool them he applied them in his booby fashion to his mouth. Some of the crumbs of the scorched skin had come away with his fingers, and for the first time in his life (in the world's life indeed, for before him no man had known it) he tasted—crackling!*

Bo-bo and his father rebuilt swiftly, then burned down the house again every time their sow produced a litter. Their feasts attracted the attention of their neighbors as word of the new delicacy spread through the village:

> *The thing took wing, and now there was nothing to be seen but fire in every direction. Fuel and pigs grew enormously dear all over the district.... People built slighter and slighter every day, until it was feared that the very science of architecture would in no long time be lost to the world.*

It took a while to realize that meat could be cooked "without the necessity of consuming a whole house to dress it." According to Lamb, roasting on a spit was invented a century or two later in some dynasty

or other; thus "do the most useful and seemingly the most obvious arts make their way among mankind."

To ensure a proper supply of pork in the afterlife, affluent Chinese were often buried with a cache of meat, in case they couldn't order in.

The Chinese so revered the pig that they awarded it one of twelve coveted places in their zodiac-like calendar cycle. People born in the Year of the Pig are said to live for the moment and have little ability to plan for the future, which is not surprising, in light of Bo-bo's discovery.

PORCELLIAN

In the late 1980s, members of an organization called the Short Snout Society gathered in Greenville, South Carolina, for their annual Swine Ball. They dressed up in pig costumes, entertained each other with skits and songs about pigs, and capped the festivities with a banquet of roast pork.

Of greater longevity is the Porcellian Club, an organization for Harvard men that is the oldest continuously operating social club in America. The Porcellian's history began when Joseph McKean, class of

1794, served a roast pig to some fellow students, an event commemo-
rated in the club song:

> *Here's a health to our Founder McKean.*
> *That man of immaculate Fame,*
> *Whose heart was so big,*
> *Who nourished a pig,*
> *And gave us our time-honored name.*

McKean's friends took to calling their group the Pig Club, and by the
time their founder graduated they had traded up to the more elegant-
sounding Porcellian. The club takes in about a dozen undergraduates
each year; its roster is dominated by Cabots, Lodges, and other
Brahmins. Enthusiastic big-game hunter Teddy Roosevelt, class of
1880, donated a number of the boar's-head trophies that line the walls
of the club's banquet hall. When he wrote to Kaiser Wilhelm of
Germany announcing the engagement of his daughter, Alice, to
banker Nicholas Longworth, the president confided, "Nick and I are
both members of the Porc, you know." It's said that the greatest
disappointment in the life of Franklin D. Roosevelt, '04, was that he
had to settle for membership in the slightly less patrician Fly Club.

When a new member of the Porc is initiated, he is dressed in a
green jockey's uniform, paraded blindfolded through the streets of
Boston, and led across the threshold of the clubhouse for the first
time. The initiate is made to kiss the snout of a roasted boar while
senior members sing hymns to friendship. Membership is for life,
even for those who go astray. In 1938 Richard Whitney, '11, a four-time
president of the New York Stock Exchange, was sentenced to serve a
term of five to ten years in Sing Sing for securities theft. Fellow
members were dismayed to see the gold Porcellian pig on Whitney's
watch chain in photographs of the fallen financier on his way to prison.

The Porcellian clubhouse, on Massachusetts Avenue in Cambridge,
shares its building with a clothing store and a Chinese restaurant. The
entrance to the club is marked only by a discreet black door with a
boar's head above it. Nonmembers are not allowed in, although
exceptions were made for Al Smith, Winston Churchill, and Dwight D.
Eisenhower. When General Eisenhower indicated that he might enjoy
a second visit, his host had to discourage him—club protocol could
be bent once, but not twice.

Many members wear green ties with pigs on them; most have a few porcine mementoes. The club is said to own a fine collection of pig artifacts, including a sculpture by Alexander Calder of two pigs in a compromising position. However, neither reporters nor photographers are allowed on the premises to verify these rumors.

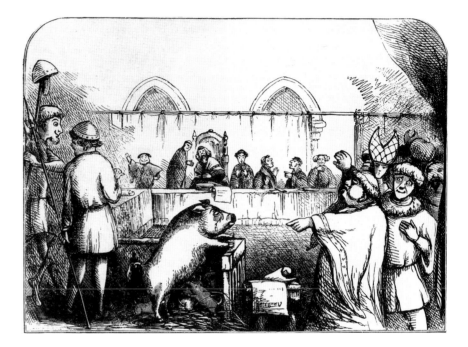

Trial of a Sow and Pigs at Lavegny. Illustration from *The Book of Days: A Miscellany of Popular Antiquities.* English. Nineteenth century. Facsimile edition, Detroit, Gale Research Co., 1967. General Research Division, The New York Public Library. Astor, Lenox and Tilden Foundations

In 1457 a sow and six of her piglets were indicted and tried in Lavegny, France, on charges of having murdered and eaten a child. The sow was convicted and condemned to death; her piglets were acquitted because of their youth.

BAD PIG

"NEITHER CAST YE YOUR PEARLS BEFORE SWINE LEST THEY TRAMPLE THEM UNDER THEIR FEET." MATTHEW 7:6

Pigs have always been associated with humanity's most unattractive traits: gluttony, sloth, stubbornness, and promiscuity. Pigs wallow in muck; they produce huge litters; they eat garbage; they won't budge unless they want to. They have been perceived as the most loathsome of the barnyard animals. People seem to equate pigs' massive bulk and the fact that they are built low to the ground with some moral imperfection. And then the poor beasts make it worse by rooting. So close to the earth and so far from God.

To call someone a pig implies that the person is insensitive, gluttonous, sexist, rapacious, odious, brutal, or all of the above. "Swine" and "hog" are no better. Contempt for the pig is commonplace in our language: "don't buy a pig in a poke"; "you live in a pigsty"; "let's pig out"; "male chauvinist pig"; "pig-headed"; "sweating like a pig";

"slippery as a greased pig"; "you can't make a silk purse out of a sow's ear." There is nothing a pig can do to improve his image; as the English say, "A pig in the parlour is still a pig."

Pigs have always had a terrible reputation. Jesus cured two lunatics from the city of Gadara by transferring their demons to a herd of pigs; the image of crazed Gadarene swine committing suicide by jumping into the sea was familiar to medieval Christians. Dante's gluttons wallow in garbage in the Third Circle of Hell; one of them is called Ciacco, the Hog. Thomas Bewick, an eighteenth-century English naturalist who couldn't resist the impulse to moralize, wrote:

> *The Common Hog is of all other domestic quadrupeds, the most filthy and impure: Its form is clumsy and disgusting, and its appetite gluttonous and excessive. In no instance has Nature more conspicuously shewn her economy than in this race of animals, whose stomachs are fitted to receive nutriment from a variety of things that would be otherwise wasted: the refuse of the field, the garden, the barn, and the Kitchen, affords them luxurious repast. [The pig is] useless during life, and only valuable when deprived of it.*

FOOD TABOOS

One-third of the world's population would rather die than eat the flesh of pigs; many of their ancestors made just that choice. During the Inquisition, Jews whose conversion to Catholicism was suspect had to prove they had renounced their former faith by eating pork. Those who balked were on their way to the stake.

In 1857 Muslim soldiers—known as *sepoys*—serving with the British army in India refused to use new Enfield rifle cartridges that were allegedly greased with pork fat. The rumor was unfounded, but the Sepoy Mutiny spread through the Punjab and the Deccan, turning within weeks into a full-fledged Anglo-Indian war. It took the British more than a year to quash the rebellion; they burned villages across north-central India, killing thousands of innocent civilians. Captured sepoys were strapped across the muzzles of loaded cannon and blown to smithereens.

Explanations for the origin of the taboo against pork are passionately debated. Orthodox Jews cite the word of the Lord in Leviticus 11:4: "The Swine, because it parts the hoof and is cloven-footed but

A Barometer. april 28-1862.

Charles Henry Bennett. *A Barometer: Publisher's Test of the American Market.* 1862. Pen and ink, 1⅜ × 3⅞". Henry E. Huntington Library and Art Gallery, San Marino, California

Bennett was a talented but impoverished English illustrator (a sample of his nursery-rhyme illustrations appear on pages 50–51) who struggled to support his wife and eight children. In his sketchbooks he referred frequently to what he perceived to be the frugality, or even venality, of publishers, several times caricaturing them as pigs. Here, he implicitly accused his American publisher of bending with the wind.

does not chew the cud is unclean to you; of their flesh you shall not eat, and their carcass you shall not touch." The Koran (2:173) reminds the faithful that God "hath forbidden you to eat that which died of itself, and blood, and swine's flesh."

Some secular commentators assert that the writers of the Bible were protecting their tribes from the risk of trichinosis. Others credit the patriarchs with a moral objection to pigs' unsavory lifestyle—their alleged filthiness and promiscuity, and the fact that, when distressed, sows will occasionally devour their young.

In *Cows, Pigs, Wars, and Witches*, anthropologist Marvin Harris argues that the biblical injunction against pork-eating has to do with local agricultural conditions. Nomadic tribes in a hot, arid environment do best with herds of sheep and cattle, which they can drive from pasture to pasture in search of sparse grasses. Pigs don't travel well and cannot digest grass. In oases or other settlements, pigs compete with people for the limited quantities of foods that they can eat—nuts, fruits, tubers, and above all, grain. Pigs are a good investment only for sedentary farmers who have ample supplies of grain and water.

> *The Middle East is the wrong place to raise pigs, but pork remains a succulent treat. People always find it difficult to resist such temptations on their own. Hence Jahweh was heard to say that swine were unclean, not only as food, but to the touch as well. Allah was heard to repeat the same message for the same reason: It was ecologically maladaptive to try to raise pigs in substantial numbers. . . . Better, then, to interdict the consumption of pork entirely, and to concentrate on raising goats, sheep, and cattle. Pigs tasted good but it was too expensive to feed them and keep them cool.*

Mythologists from Sir James Frazer to Joseph Campbell have pointed out that, long before the Hebrews and their God, the principal deity worshiped in the ancient world was the Mother—in both her good and bad aspects. The Hindu mother goddess, Kali, is a black sow who perpetuates the endless cycle of giving birth to the world and then eating all her offspring. In her Greek form, the mother goddess is Demeter, whose avatar is also a sow. At the great spring festival of Demeter, worshipers sacrificed pigs to ensure good crops. Some commentators suggest that Hebrew devotees of an all-powerful Father God felt it imperative to reject the animal associated with the older, matriarchal religions.

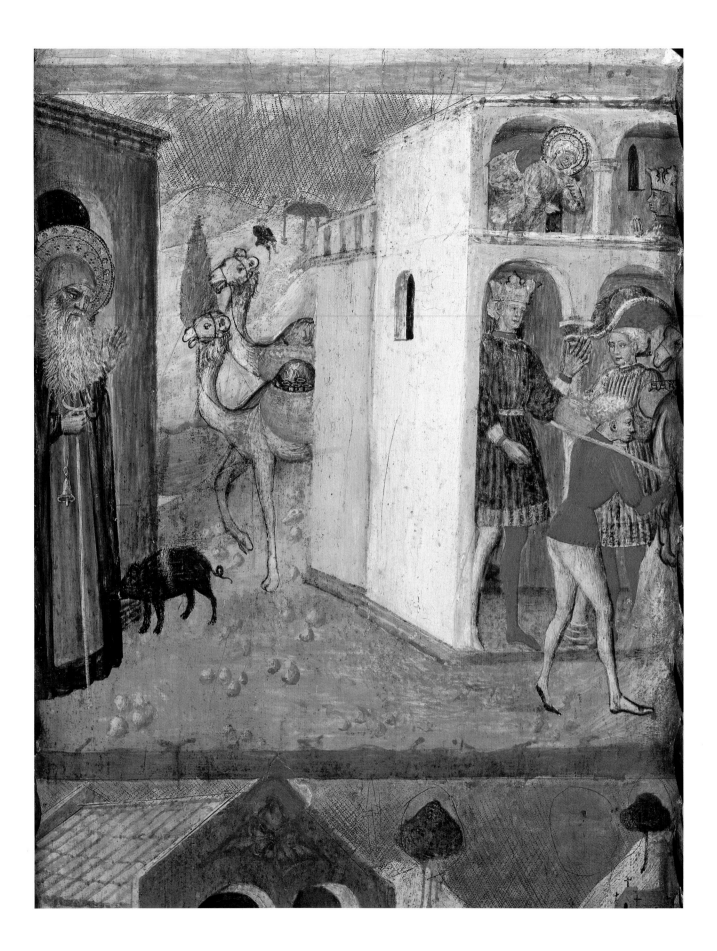

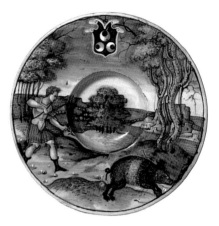

The "Milan Marsyas painter" (Urbino). *Meleager Hunting the Calydonian Boar.* c. 1530. Maiolica bowl with broad rim, 7½" in diameter. The Fitzwilliam Museum, Cambridge, England

Meleager, the son of the king of Calydon, invited the great heroes of Greece—among them Castor and Pollux, Jason, Nestor, and Atalanta—to join him in a hunt for the wild boar that was ravaging his country. The Calydonian boar hunt is a paradigm of confrontations between mythical heroes and pigs: Hercules wrestled the Erymanthian boar as one of his twelve labors; Theseus killed the wild sow of Crommyon. In historical times, the boar hunt retained its heroic dimensions. For Romans it was the noblest of sports. Great hunts were fashionable among nineteenth-century European aristocrats, and pig-sticking in India was de rigueur for socially ambitious British officers.

The Greek hero Adonis and his Asian counterparts, Tammuz and Attis, were killed by wild boars; boars became sacred to members of the heroes' cults. The pig was also important in the rites associated with the Egyptian god Osiris. Egyptians thought pigs were unclean and were forbidden to eat their flesh. Yet once a year, at a great feast dedicated to Osiris, pigs were sacrificed and eaten by the priests and their followers.

According to scholars of mythology, it was those priests of Osiris, encountered during the years of slavery in Egypt, from whom the Hebrew priests were most eager to distance themselves. If the pig was sacred to the Egyptians, it would be an abomination to the Jews.

THE SAINTS

Lurking on the undersides of wooden choir stalls, grinning from the stone capitals of Gothic columns, leering at wayfarers, pigs are a popular motif in medieval Christian art. Occasionally, the animal seems to represent nothing more than its barnyard self. More often, the pig is a symbol of gluttony, lust, or greed. Conversely, when piglets appear with Jesus or in hagiographical art, they symbolize the subjugation of those vices.

Portraits of Saint Blasius (d. 316), the martyred bishop of Sebaste in Cappadocia, Asia Minor, often include a pig's head at his feet. Blasius is sometimes depicted with an iron comb, which has been interpreted as either an instrument of his torture or a sign of his support for the wool-workers in Sebaste. As far as is known, the pig's head has nothing to do with the wool-comber trade or the manner of the martyr's death. The disembodied head is usually explained as a symbol of the bishop's victory over sensual appetites.

Saint Anthony Abbot is the saint most often portrayed with pigs. A hermit who lived in the Egyptian desert from about A.D. 250 to 355, Anthony was the first Christian monk. It is likely that Anthony's piglet, too, symbolizes the saint's denial of the flesh.

Through the years, popular lore contributed to Saint Anthony's association with pigs. Anthony was the patron saint of the Hospitallers—medieval monks who ran hospices for poor travelers. At the time, local authorities had the right to confiscate pigs running loose in the street; the Hospitallers' pigs—identified by a bell around their

necks—were exempt. As patron of the order, Anthony was seen indirectly as the protector of its pigs.

Pigs also appear in the iconography of Saint Elizabeth of Hungary. Elizabeth, who lived from about 1207 to 1231, married King Louis IV of Thuringia—a German principality—in 1221. Her extraordinary generosity to the poor of Thuringia led to her eventual canonization. When Louis died in 1227 on his way to the Holy Land on the Sixth Crusade, Elizabeth and her children were driven out of her palace by her brother-in-law. She found shelter in an inn next to a pigsty—an incident that is said to justify the symbolic pig in her portraits.

A TIME TO LIVE AND A TIME TO DIE

For more than five thousand years, humans have fashioned the pig to serve their needs. Farmers provide food and shelter for their hogs and demand in exchange that hogs forfeit their normal life expectancy. Most people do not question whether the pig is diminished by this arrangement; they accept it as the natural order of things.

The British writer John Berger has noted that, in the ancient world, animals

> were subject and worshipped, bred and sacrificed. Today the vestiges of this dualism remain among those who live intimately with, and depend upon, animals. A peasant becomes fond of his pig and is glad to salt away its pork. What is significant, and is so difficult for the urban stranger to understand, is that the two statements in that sentence are connected by an and and not by a but.

W. B. Hudson, the British naturalist, wrote:

> I have a friendly feeling towards pigs generally, and consider them the most intelligent of beasts, not excepting the elephant and the anthropoid ape. . . . [The pig] views us from a . . . sort of democratic standpoint as fellow-citizens and brothers, and takes it for granted, or grunted, that we understand his language, and without servility or insolence he has a natural, pleasant, camerados-all or hail-fellow-well-met air with us.
>
> It may come as a shock to some of my readers when I add that I like him, too, in the form of rashers on the break-fast table.

In his novel *Charlotte's Web*, E. B. White created Wilbur, the pig who is saved from becoming bacon by his friend, Charlotte. In real life, as White recounts in his essay "Death of a Pig," he fattened a piglet each year in anticipation of a November slaughter:

> *The scheme of buying a spring pig in blossomtime, feeding it through summer and fall, and butchering it when the solid cold weather arrives, is a familiar scheme to me and follows an antique pattern. It is a tragedy enacted on most farms with perfect fidelity to the original script. The murder, being premeditated, is in the first degree but is quick and skillful, and the smoked bacon and ham provide a ceremonial ending whose fitness is seldom questioned.*

One day, however, White's pig failed to show up for his supper. The pig was sick. His neighbors suggested castor oil and other home remedies. When the pig grew more listless, White called in the vet. Nothing worked; the pig died. White and his neighbors grieved. The pig's premature death was an affront. "The loss we felt was not the loss of ham, but the loss of pig. He had evidently become precious to me, not that he represented a distant nourishment in a hungry time, but that he had suffered in a suffering world."

Once a pig's misery is acknowledged, his end becomes problematic. The hero of Thomas Hardy's novel *Jude the Obscure* fattened a pig through summer and fall with the intention of feeding his impoverished family through the winter. When the village slaughterer didn't arrive to kill the pig, Jude and his wife had to do it themselves.

> *Jude, rope in hand, got into the sty, and noosed the affrighted animal, who, beginning with a squeak of surprise, rose to repeated cries of rage. Arabella opened the sty-door, and together they hoisted the victim on to the stool, legs upward, and while Jude held him Arabella bound him down, looping the cord over his legs to keep him from struggling.*
>
> *The animal's note changed its quality. It was not now rage, but the cry of despair; long-drawn, slow and hopeless.*
>
> *"Upon my soul, I would sooner have gone without the pig than have had this to do!" said Jude. "A creature I have fed with my own hands."*
>
> *"Don't be such a tender-hearted fool!"*

Jude botched the job but finished off the pig just as the butcher arrived. He "felt dissatisfied with himself as a man at what he had

done. . . . The white snow, stained with the blood of his fellow-mortal, wore an illogical look to him as a lover of justice, not to say a Christian; but he could not see how the matter was to be mended. No doubt he was, as his wife had called him, a tender-hearted fool."

FELLOW MORTALS

Winston Churchill once observed that dogs look up to us, cats look down on us, but pigs treat us as equals. Perhaps it is their intelligence, or their sense of self, that gives us this impression. Perhaps it is their sensitivity or moodiness. Piglets are remarkably

Roman, found at Herculaneum. A.D. 1–50. Bronze. Museo Nazionale, Naples

inquisitive and affectionate; mature pigs are responsive, sensible, and brave. They have been known to jump into water to rescue drowning children. Their eyes gaze at us with fierce concentration; some people even see in pigs' eyes a foreknowledge of their early doom.

The complex relationship between humans and pigs has inspired artists since earliest times. Thirteen thousand five hundred years ago, cave painters at Altamira portrayed wild boar as the object of the hunt. Jade and pottery pigs, some dating from the twelfth century B.C.,

Alas poor Porick : I knew him well, he was one of
CHAS. COUNSELMAN & CO'S
ROYAL HAMS

O, he would set the table in a roar when he came on.

HAM LET.

Ham Let. Alas Poor Porick. Color-lithographic trade card by J. M. W. Jones S. & P. Co., Chicago, for Chas. Counselman & Co., the purveyors of Royal Hams. c. 1870. Collection Frances Converse Massey

The Tail-Piece. Illustration from *The Headlong Career and Woful [sic] Ending of the Precocious Piggy*, by Thomas Hood. Illustrated by his Son. Boston, M. A. Mayhew, 1860. Collection Frances Converse Massey

were buried with Chinese noblemen to insure wealth in the world to come. Egyptians, Assyrians, Indians, Greeks, and Romans displayed pigs on coins, amulets, and votive objects.

Medieval Christian art both canonized and anathemized pigs. Renaissance painters commemorated the struggle between mythic heroes and savage boars as well as the enduring passion of aristocrats for the hunt. Genre painters captured the dignity of corpulent hogs in the barnyard and the affectionate bonds between sows and their young. They also memorialized prize pigs and the masters who bred them for market. Folk artists translated the roundness and sheer bulk of pigs into homey household objects like weathervanes, jugs, and piggy banks.

In illustrated books for children, pigs are unabashedly cute. At worst, they are a little foolhardy; at best, they are loving and clever. They always outwit the wolf.

Pigs never outwit us. In every age, depictions of rural life chronicle the slaughter and the transformation of pig into pork. Contemporary artists have documented the short, unhappy life of pigs in vast commercial breeding farms and packing houses. Even neutral images of portly pigs lazing in the sun raise questions about who is feeding them and to what end.

People worry about pigs. Pigs are so compelling, so mysterious, so contradictory—finicky yet fat, massive yet dainty, stolid yet smart. We can't decide what we think of them. We're uneasy about our role in their life and death. We make images of them that reveal our complex feelings—our affection, our revulsion, our sentimentality, and our guilt.

We rejoice when a pig escapes its man-made fate. We are moved by Wilbur's salvation; we are awed by Miss Piggy's indomitable spirit. We celebrate that they and their kind survive, immortalized in art.

The Tail-Piece.

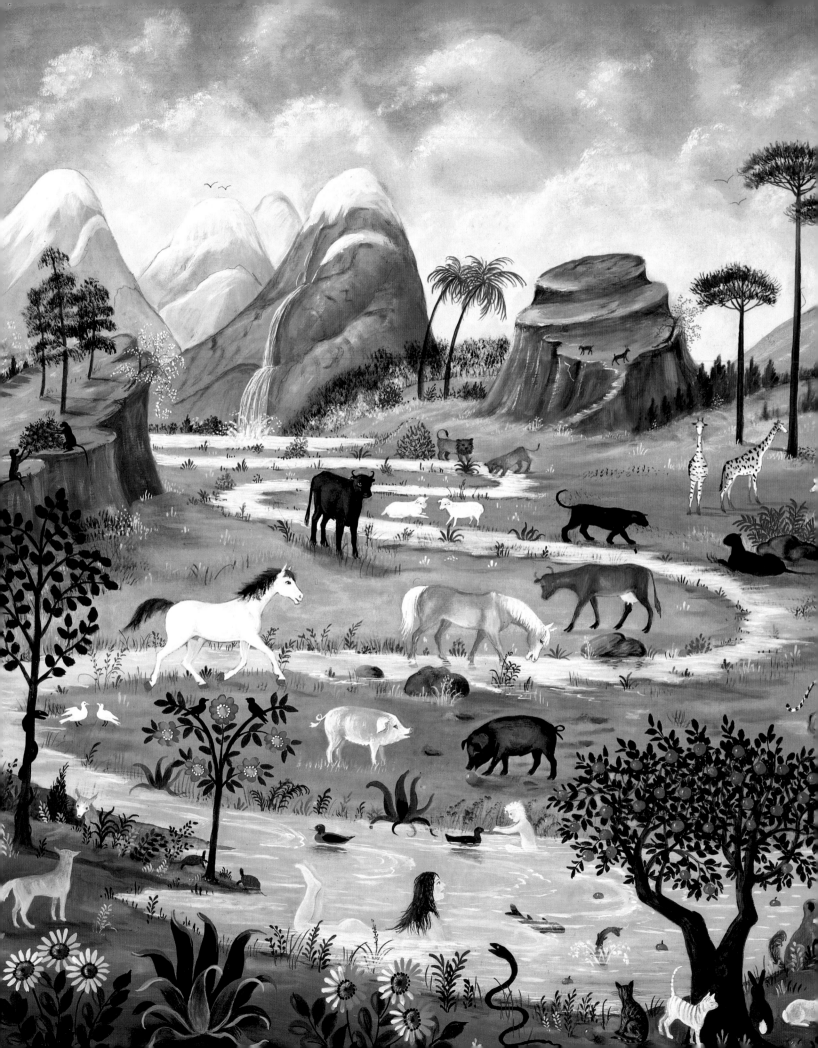

Under your mighty ancestors, we pigs
Were bless'd as nightingales on myrtle sprigs,
Or grass-hoppers that live on noon-day dew
And sung, old annals tell, as sweetly too. . . .

From Oedipus Tyrannus, *by Percy Bysshe Shelley*

Martha Cahoon (American). *Garden of Eden*. c. 1970. Oil on Masonite, 24¾ × 26½". Courtesy The Cahoon Museum of American Art, Cotuit, Massachusetts

PART ONE: THIS LITTLE PIG

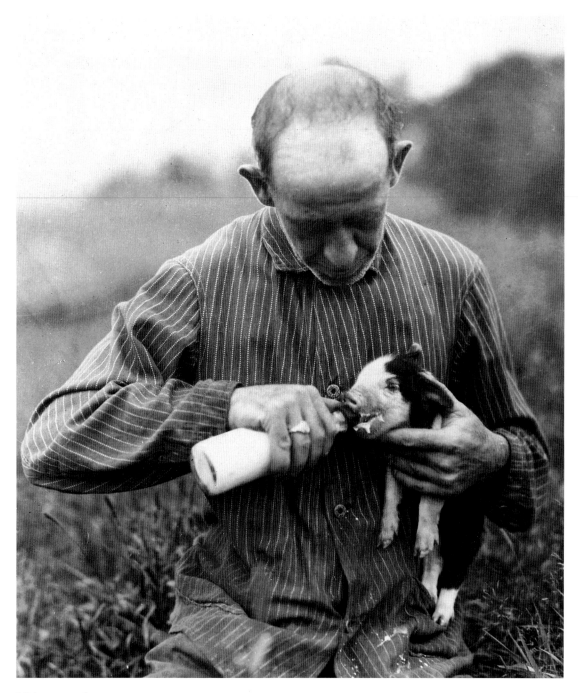

Midwestern farmer. 1920s

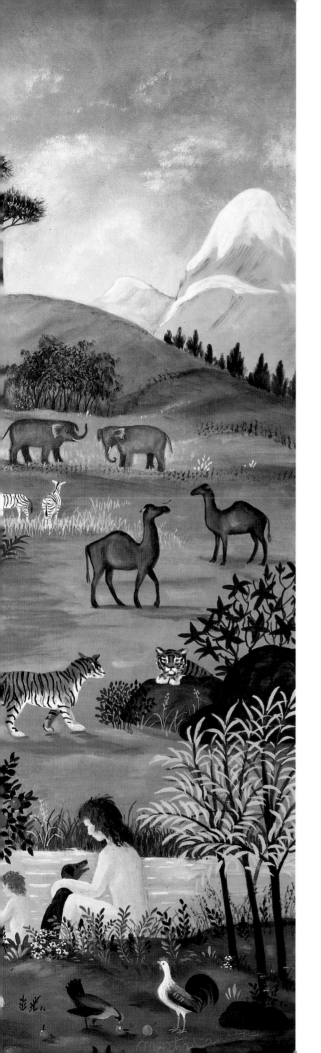

Under your mighty ancestors, we pigs
Were bless'd as nightingales on myrtle sprigs,
Or grass-hoppers that live on noon-day dew
And sung, old annals tell, as sweetly too. . . .

From Oedipus Tyrannus, *by Percy Bysshe Shelley*

Martha Cahoon (American). *Garden of Eden*. c. 1970. Oil on Masonite, 24¾ × 26½″. Courtesy The Cahoon Museum of American Art, Cotuit, Massachusetts

PART ONE: THIS LITTLE PIG

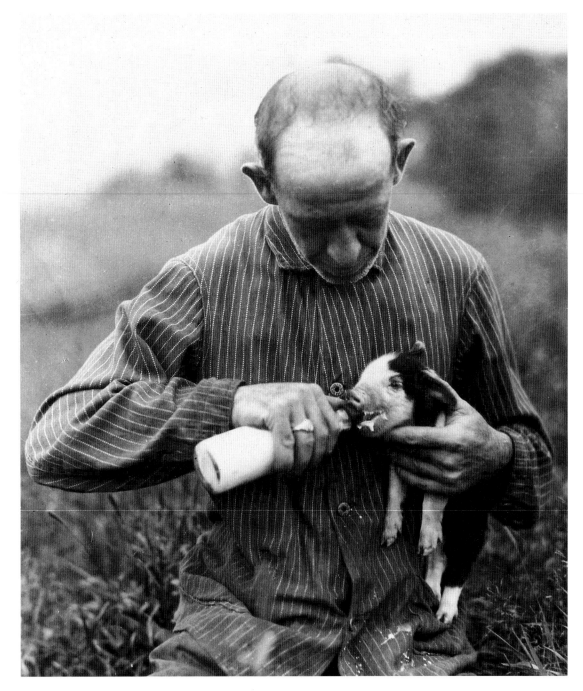

Midwestern farmer. 1920s

Alice

Little Pink Pigs and none of them lean,
Patches like truffles on satin-pink skin,
More or less aping a nice galantine
 Dappled with sun,
Busily scampering Devil-may-care:
Fat little backs have a shimmering air
Glossily quivering everywhere,
 Jelly, each one.

From "Les Cochons Roses," by Edmond Rostand

Fabergé. Objet de vertu.
Late nineteenth century.
Rhodonite with
diamond eyes,
$1\frac{7}{8} \times 3 \times 1\frac{3}{8}$".
Courtesy
A la Vieille Russie,
New York

Nellie Mae Rowe (American). Untitled. 1978. Pencil and crayon on paper,
$7\frac{1}{2} \times 22\frac{1}{2}$". Courtesy Ricco/Maresca Gallery, New York

Rowe (1900–1982), who lived all her life in rural Georgia, specialized in paintings and
sculptures of animals and country scenes. She once said, "Drawing is the only thing I
think is good for the Lord. When I wake up in Glory, I want to hear, 'Well done, Nellie,
well done.'"

Earrings. Designed by
Rochelle Epstein, made by
Debra Healy (American).
1988. Enamel on 18-carat
gold. Private Collection

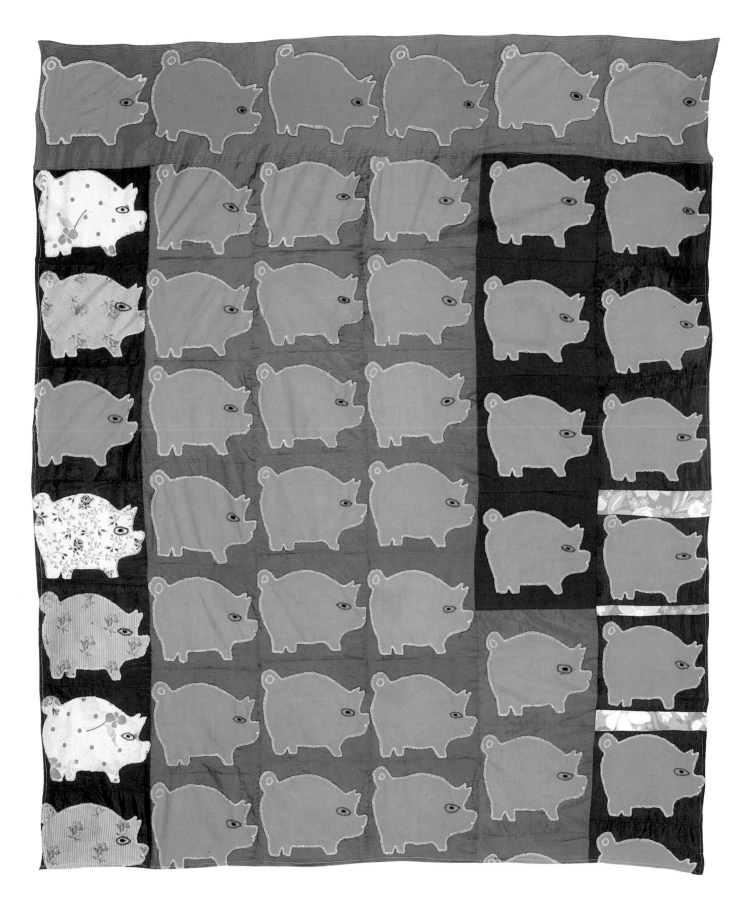

Appliquéd top for a quilt. American. c. 1950. America Hurrah, New York

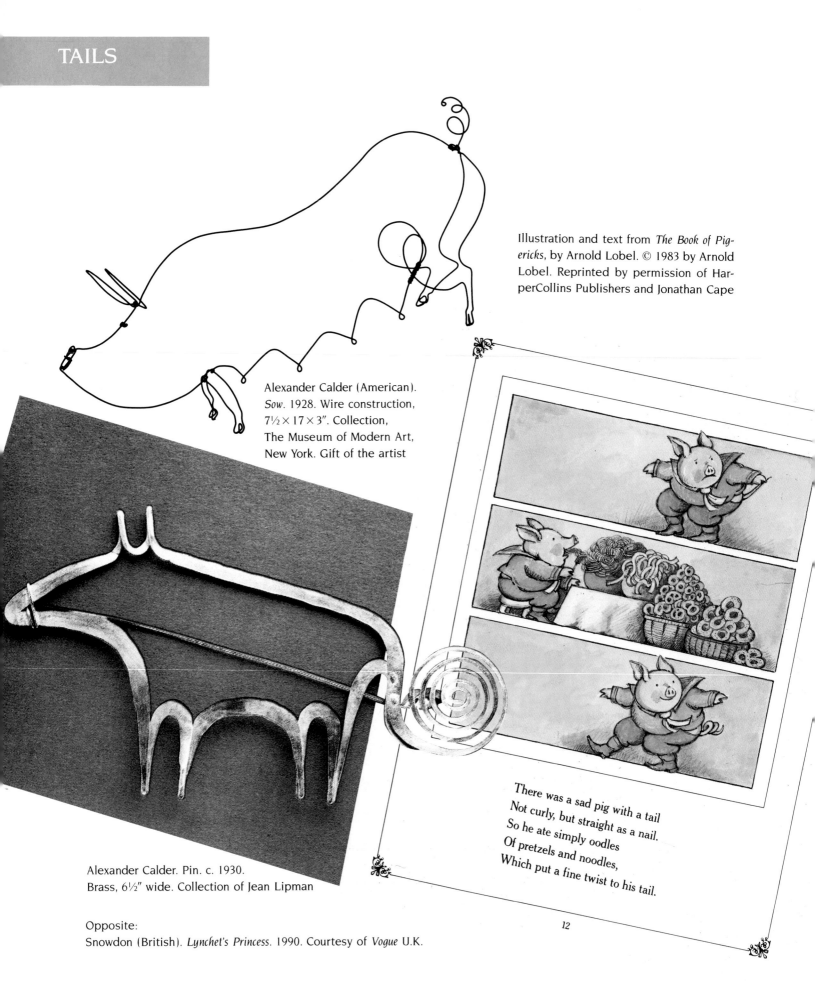

Illustration and text from *The Book of Pig-ericks*, by Arnold Lobel. © 1983 by Arnold Lobel. Reprinted by permission of HarperCollins Publishers and Jonathan Cape

Alexander Calder (American). *Sow*. 1928. Wire construction, 7½ × 17 × 3″. Collection, The Museum of Modern Art, New York. Gift of the artist

There was a sad pig with a tail
Not curly, but straight as a nail.
So he ate simply oodles
Of pretzels and noodles,
Which put a fine twist to his tail.

12

Alexander Calder. Pin. c. 1930.
Brass, 6½″ wide. Collection of Jean Lipman

Opposite:
Snowdon (British). *Lynchet's Princess*. 1990. Courtesy of *Vogue* U.K.

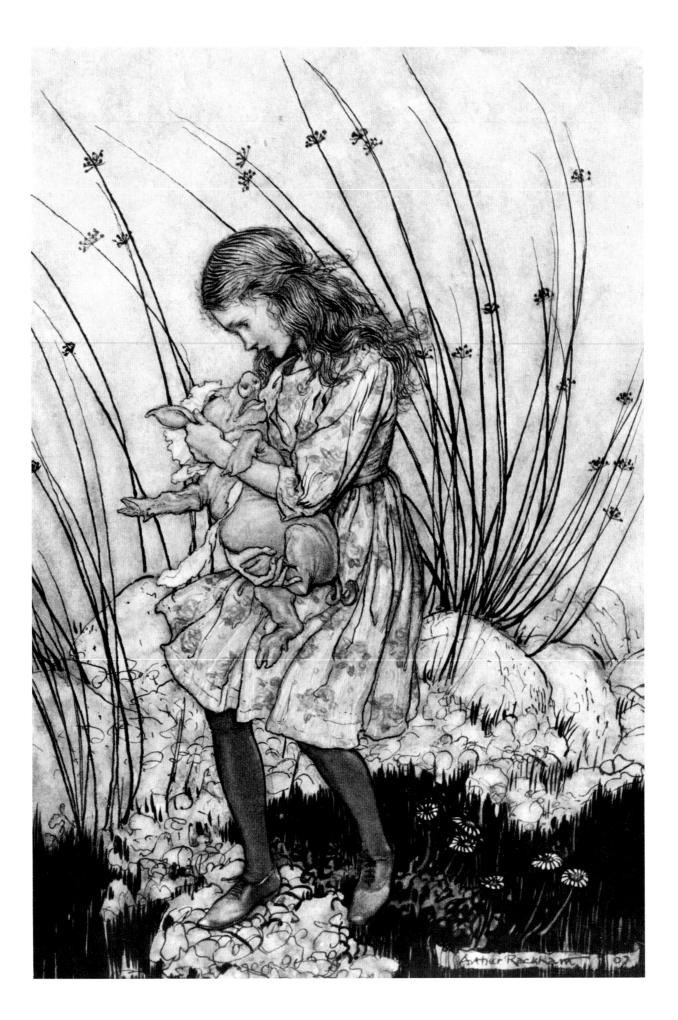

Chromolithographic postcards. European. c. 1900.
Collection Frances Converse Massey

Opposite:
Arthur Rackham. Illustration
from *Alice's Adventures in Wonderland*,
by Charles Dodgson (Lewis Carroll).
London, Wm. Heinemann, 1907.
Collection Frances Converse Massey

E. H. Shepard (English). *Christopher Robin at the Enchanted Place*.
1925–30. Watercolor on paper, 14½ × 10½". Private Collection.
Printed by permission of Curtis Brown, Ltd. Copyright
© 1991 by Lloyd's Bank plc and the E. H. Shepard Trust

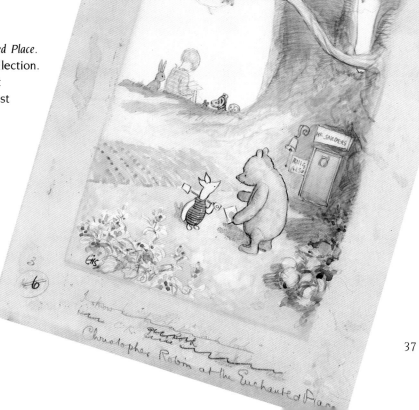

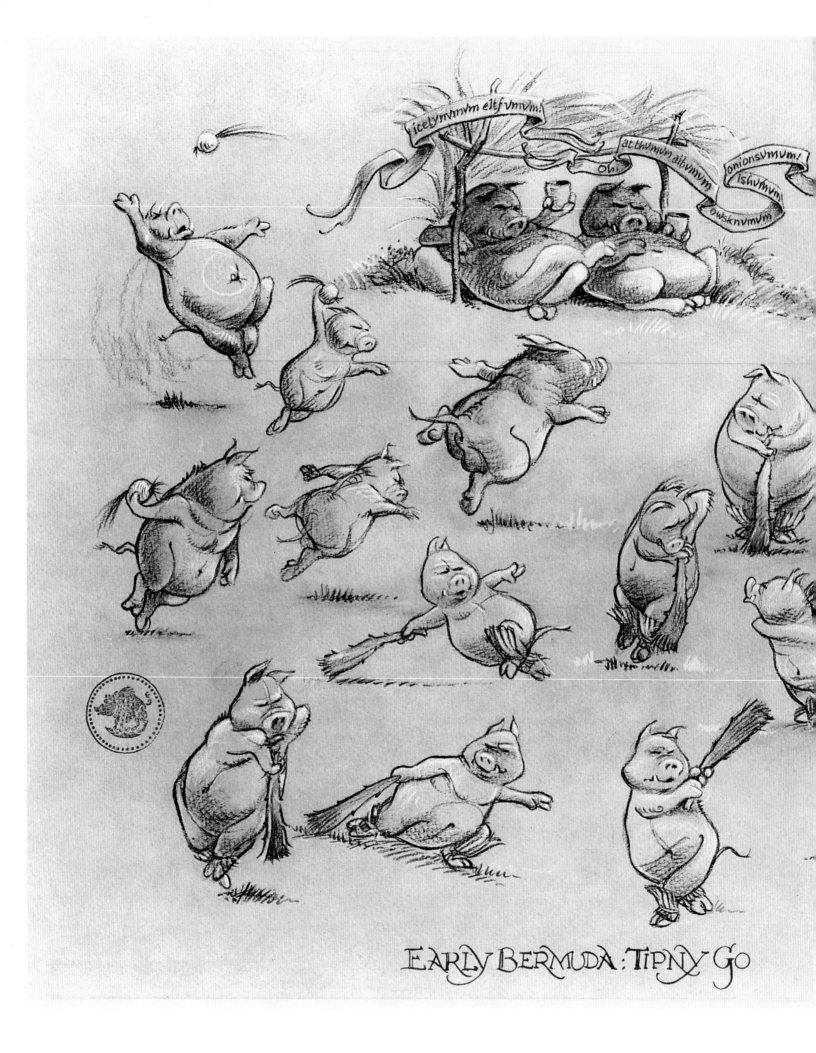

EARLY BERMUDA: TIPNY GO

Michael K. Frith (Bermudian-American). *Tipny-Go*. 1984. Pastel, pencil, and watercolor, 22½ × 17". © 1984, Trudy Trees, Inc. Collection Mrs. I. Susan Outerbridge. Published in *The Early Bermudians*, by M. K. Frith. A Trudy Trees, Inc./Windjammer Gallery Production, 1985

During the Age of Exploration, European sailors who passed by Bermuda reported terrible screams emanating from the island. They dubbed it "the Isle of Devils" and gave it wide berth. In 1609 a British fleet bearing settlers to Virginia was caught in a terrible storm, and its flagship wrecked on Bermuda's reefs. The grateful survivors found not only a verdant paradise but a well-stocked larder: The island was aswarm with wild pigs—presumably the survivors of an earlier wreck and the source of the demonic sounds.

In 1984 Michael K. Frith, executive vice-president of Jim Henson Productions and a proud Bermudian, observed the 375th anniversary of the human settlement of his homeland by writing and illustrating his own version of its history. It features the original porcine population and chronicles the pigs' tragic defeat at the hands of British invaders in the infamous "Boar Wars." Tipny-Go, *according to Frith, was a primitive form of ritual combat in which champions from various parts of the islands hurled sacred onions at a banana impaled on three sticks, guarded by a native armed with a palmetto stalk. Had the pigs invented cricket?*

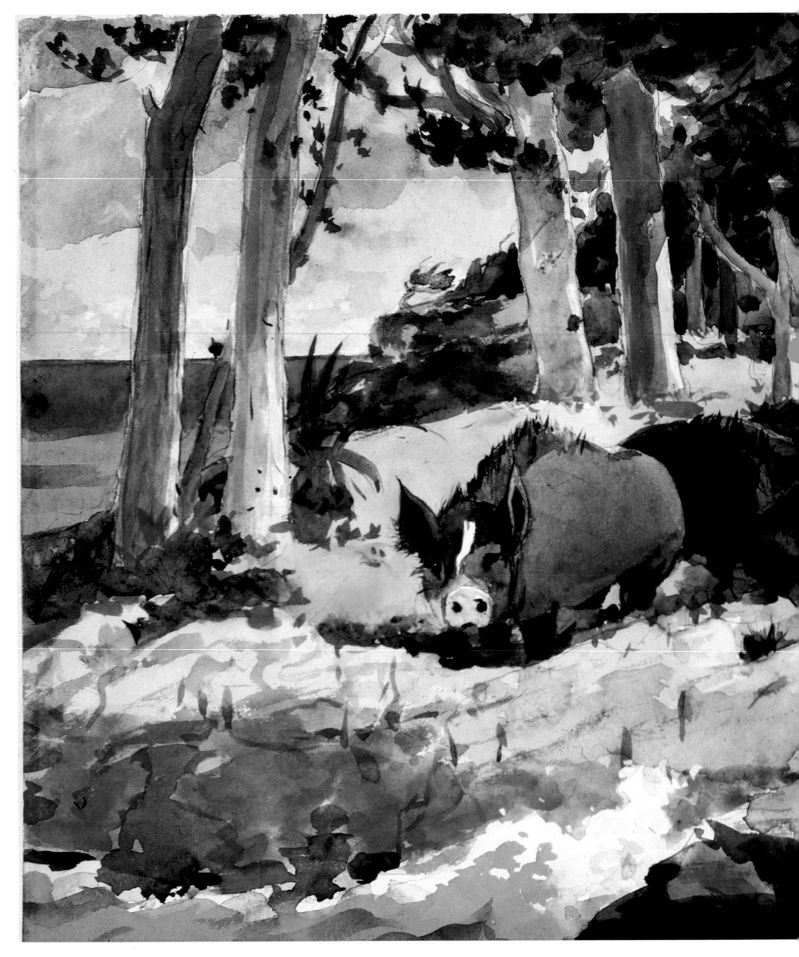

Winslow Homer (American).
Bermuda Settlers. 1901.
Watercolor over graphite
on cream wove paper,
12½ × 19″. Worcester Art
Museum, Massachusetts

RIDING A PIG

Carousel pig. French. c. 1900. Carved and painted wood, 14 × 30 × 8″. Collection Marcia Carter

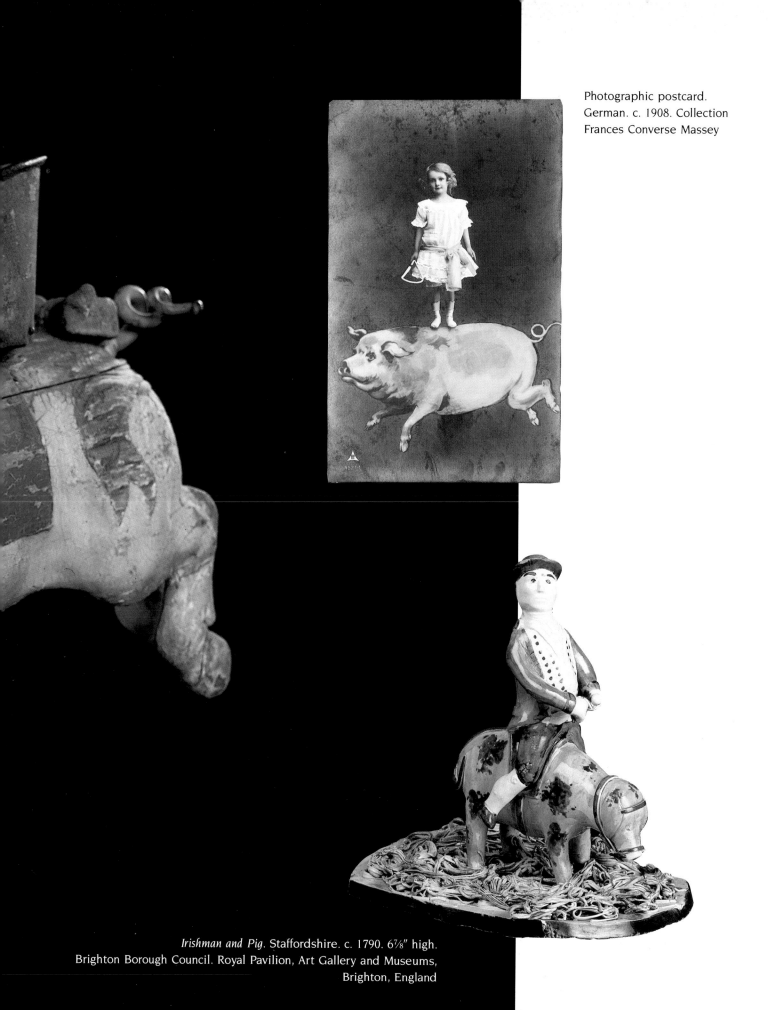

Photographic postcard.
German. c. 1908. Collection
Frances Converse Massey

Irishman and Pig. Staffordshire. c. 1790. 6⅞″ high.
Brighton Borough Council. Royal Pavilion, Art Gallery and Museums,
Brighton, England

They're Off! The start of the Ladies' Pig-Driving Contest at Pinehurst, North Carolina. No date

Clockwork mechanical toy. Manufactured by Juneau. French. c. 1880. Doll with bisque head and rag body, pigskin-covered pigs, and metal wagon, 16″ long. Collection Vernon E. Chamberlain

Postcards. Various countries. Early twentieth century. Collection of the authors

In central Europe, pigs have traditionally been the bearers of good luck wishes for the New Year. Marzipan pigs are a holiday treat, and New Year's cards frequently depict jolly pigs with sacks of gold, four-leaf clovers, or horns of plenty, all of which symbolize good fortune for the coming year.

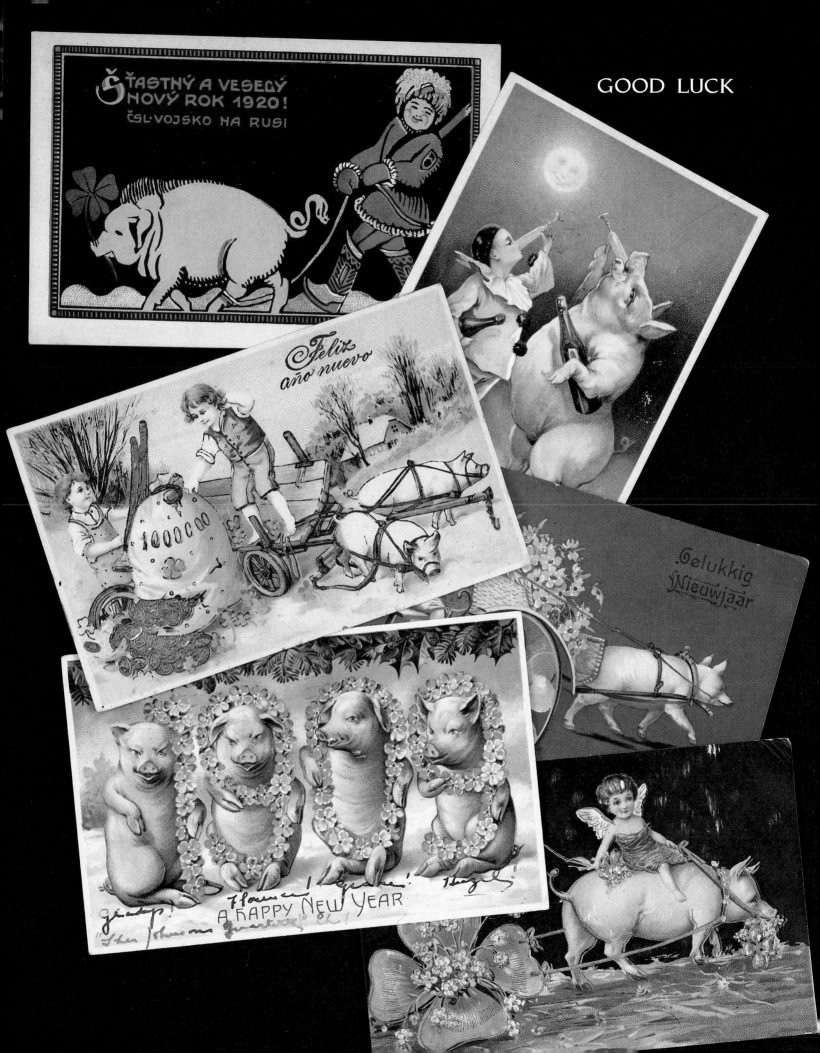

GOOD LUCK

"But how can I be sure it's not just for my money?"

Drawing by Chas. Addams. © 1973 The New Yorker Magazine, Inc.

The Wise Pig. American. c. 1900. Still bank, with slot on back of head. Marked THE WISE PIG. SAVE A PENNY YESTERDAY/ANOTHER SAVE TODAY/TOMORROW SAVE ANOTHER/TO KEEP THE WOLF AWAY. THRIFTY. Cast iron, 6¾" high on 1¾"-square base. Shelburne Museum, Vermont

Money boxes. Javanese. Fourteenth century. Sparpotten Museum, Amsterdam

The origins of pig-shaped coin banks are obscure. Perhaps the inspiration comes from the association of pigs with good luck. Another possible explanation is that during the Middle Ages a common clay called pygg was used for making earthenware pots—the kind of kitchen jar or bowl in which a household might keep its ready cash. Over the years, people may have confused the word with its homonym, and by the eighteenth century, potters were making little savings banks in the shape of pigs.

The British Museum owns an Egyptian glazed pottery pig, dating from the first century B.C. or A.D., which has an opening in its back. Although it looks surprisingly like a piggy bank, most probably it is an oil lamp. Two British experts who looked into the matter several decades ago could not substantiate any claims for piggy banks made before the eighteenth century, which is not surprising since such objects are intended to be broken open and discarded.

Souvenir still bank from the World's Fair of 1904, St. Louis. Painted ceramic, $3 \times 4\frac{1}{4} \times 2\frac{1}{8}$″. Shelburne Museum, Vermont

Walter Crane. Illustration from *This Little Pig Went to Market*. London and New York, John Lane, 1895. Collection Frances Converse Massey

"This Little Pig Went to Market" may be the most famous example in English of a counting rhyme for children. Pigs figure frequently in counting rhymes in several languages, perhaps because, unlike cows and goats and other barnyard animals, sows have big litters—more than enough piglets for each digit.

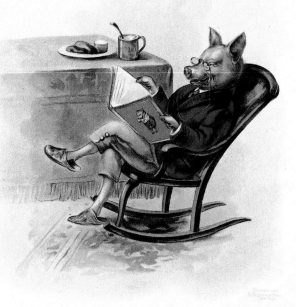

Illustration from *The Five Little Pigs*. New York, McLouglin Bros., c. 1905. Collection Frances Converse Massey

The Pig that Stayed at Home

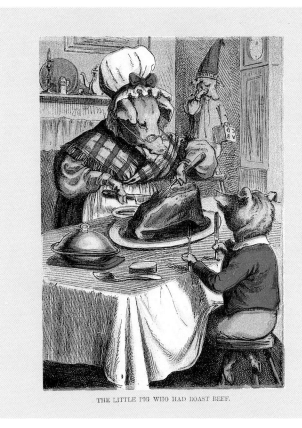

THE LITTLE PIG WHO HAD ROAST BEEF.

Illustration from *Five Little Pigs*. New York, McLouglin Bros., c. 1880. Collection Frances Converse Massey

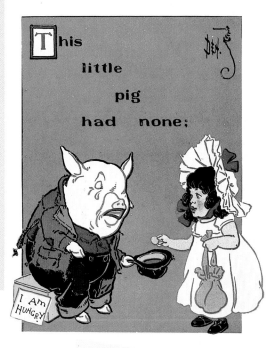

Above right:
W. W. Denslow. Illustration from *Five Little Pigs*. Chicago, M.A. Donohue & Co., 1903. Collection Frances Converse Massey

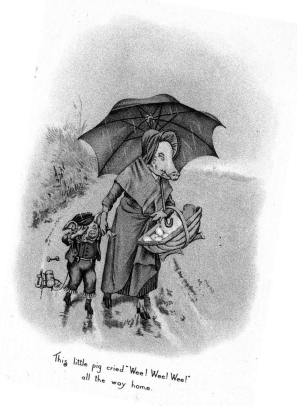

W. Weekes. Illustration from *This Little Pig Went to Market*. Boston, John P. Squire & Co., c. 1880. Collection Frances Converse Massey

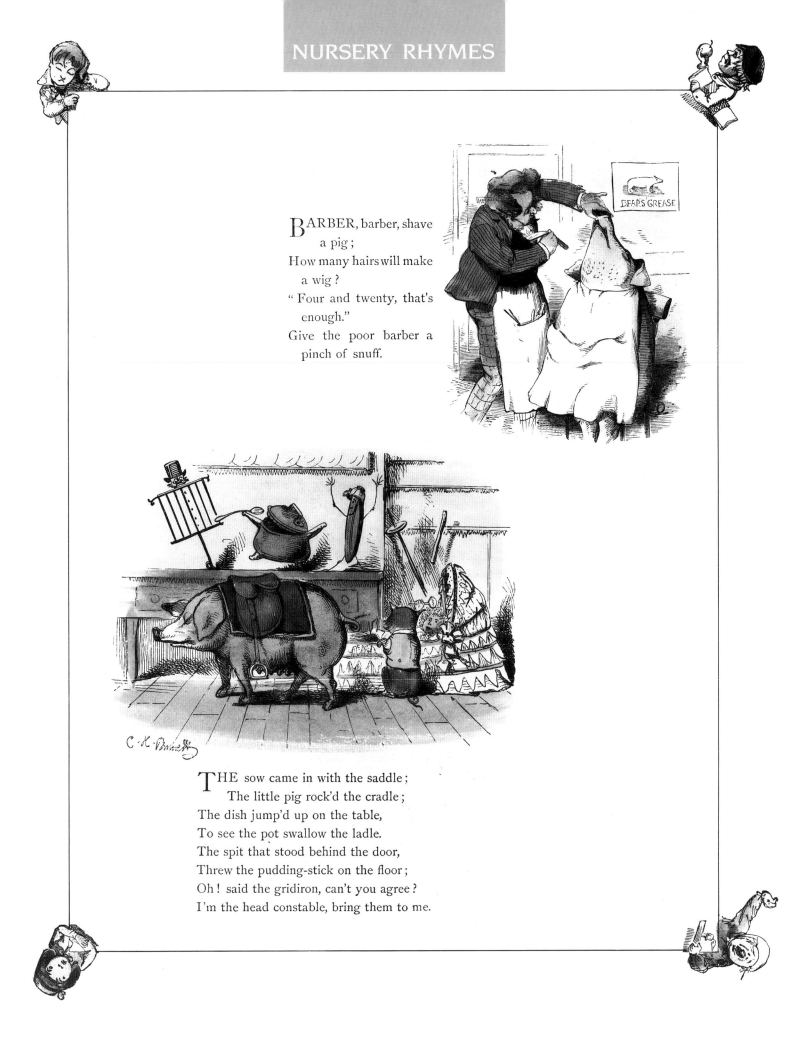

BARBER, barber, shave
a pig;
How many hairs will make
a wig?
" Four and twenty, that's
enough."
Give the poor barber a
pinch of snuff.

THE sow came in with the saddle;
The little pig rock'd the cradle;
The dish jump'd up on the table,
To see the pot swallow the ladle.
The spit that stood behind the door,
Threw the pudding-stick on the floor;
Oh! said the gridiron, can't you agree?
I'm the head constable, bring them to me.

A LONG-tailed pig, or a short-tailed pig,
 Or a pig without a tail;
A sow pig, or a boar pig,
 Or a pig with a curly tail.

UPON my word and
 honour,
As I was going to
 Bonner,
I met a pig,
Without a wig,
Upon my word and
 honour.

Charles Bennett. Illustrations from
Old Nurse's Book of Rhyme, Jingles, Ditties. London, Griffith & Farran, 1865.
General Research Division, The
New York Public Library. Astor,
Lenox and Tilden Foundations

TOM, Tom, the piper's son,
 Stole a pig, and away he run!
The pig was eat, and Tom was beat,
And Tom went roaring down the street.

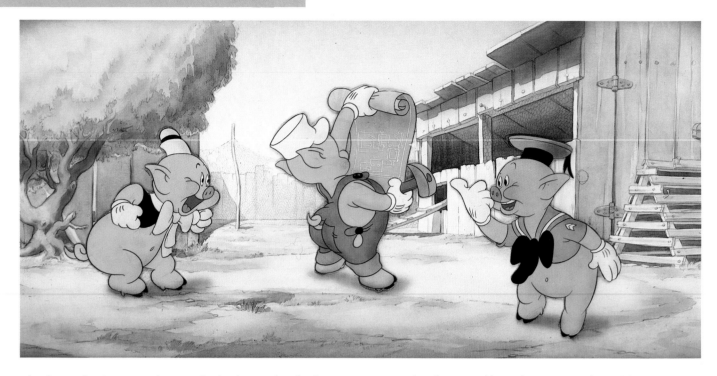

The Three Little Pigs. Original watercolor background and cel painting. Prepared and mounted by Walt Disney Studio, 1933.
© The Walt Disney Company. Private Collection

Cigarette and match holder, with match striker. c. 1890. Continental majolica, 6 × 6 × 3". Karmason-Stacke Collection

"The Sow and the Wolf"

A Sow that had just farrowed, and lay in her sty with her whole litter of Pigs, was visited by a Wolf, who secretly longed to make a meal of one of them but knew not how to come at it. So, under the pretense of a friendly visit, he gave her a call and endeavored to insinuate himself into her good graces by his apparently kind enquiries after the welfare of herself and her young family.

"Can I be of service to you, Mrs. Sow?" said he. "If I can, it shall not on my part be wanting; and if you have a mind to go abroad for a little fresh air, you may depend upon my taking as much care of your young family as you could do yourself."

"No, I thank you, Mr. Wolf. I thoroughly understand your meaning, and the greatest favor you can do to me and my Pigs is to keep your distance."

From Thomas Bewick's Select Fables of Aesop

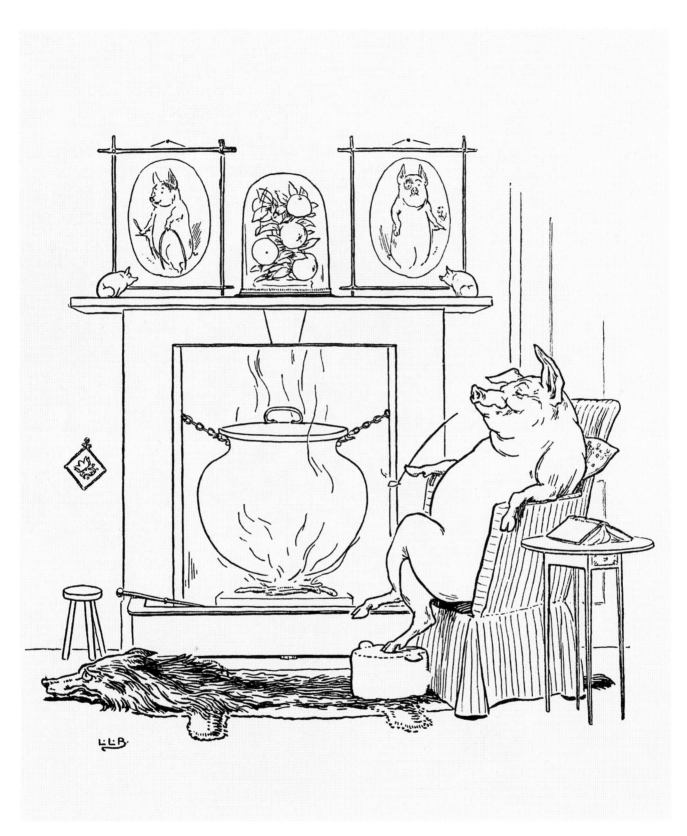

L. Leslie Brooke. Illustration from *The Three Little Pigs and Tom Thumb*. London, Frederick Warne & Co., c. 1922. Collection Frances Converse Massey

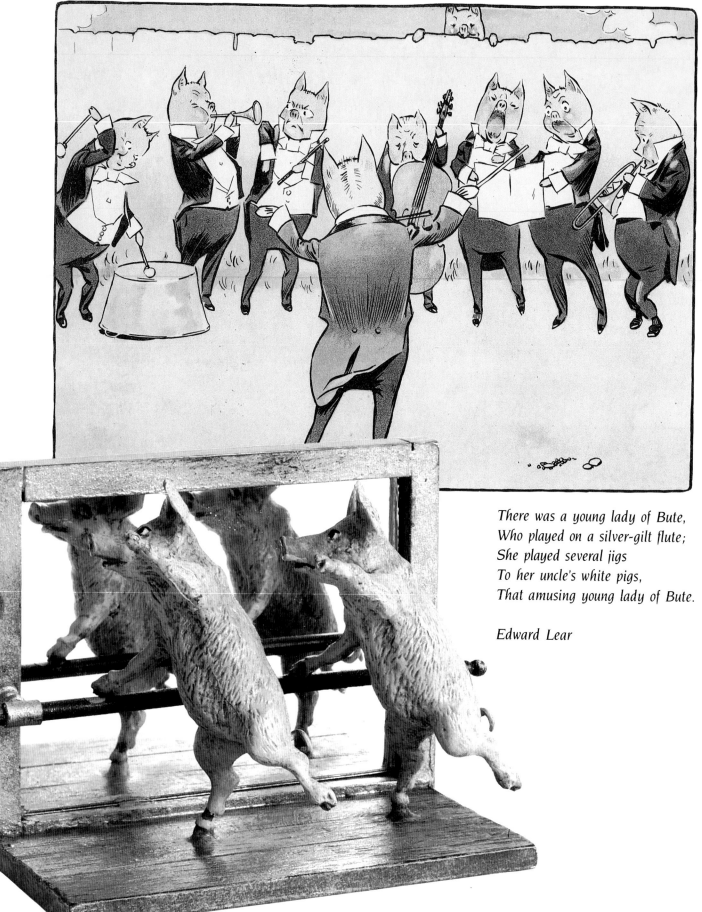

There was a young lady of Bute,
Who played on a silver-gilt flute;
She played several jigs
To her uncle's white pigs,
That amusing young lady of Bute.

Edward Lear

Opposite, above:
Lewis Baumer. *The Pigs' Orchestra*.
Illustration from *Did You Ever?*
London, W. & R. Chambers, Ltd.,
c. 1905. Collection Frances Converse
Massey

Opposite, below:
At the Barre. German. Late
nineteenth century.
Assemblage: gilded and
painted metal and mirror,
$2\frac{1}{2} \times 3\frac{3}{8} \times 2''$. Collection
Frances Converse Massey

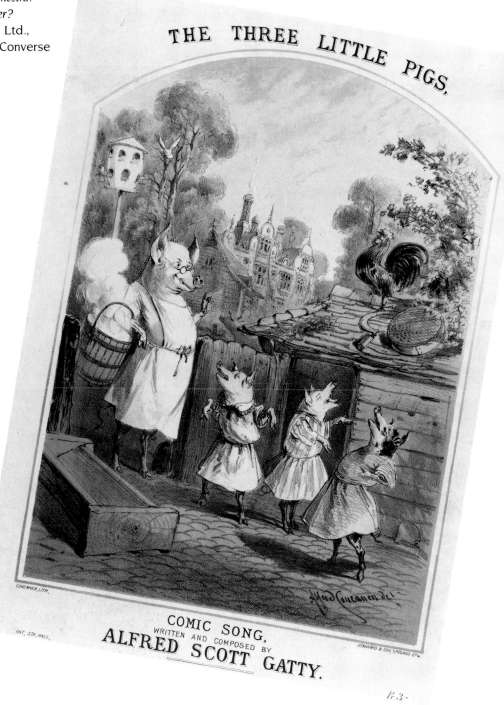

The Three Little Pigs. A Comic Song Written and Composed
by Alfred Scott Gatty. Sheet music. London, Robert Cocks & Co., c. 1869.
Collection Frances Converse Massey

Bill Peet. Illustration from *Chester the Worldly Pig*, by Bill Peet. Copyright © 1965 by Bill Peet. Reprinted by permission of Houghton Mifflin Co.

Pig on a Tightrope. Designed and executed by Edward Gorey (American). 1989. Needlepoint: tent-stitched wool, $8\frac{5}{16} \times 6\frac{5}{8}$". Collection Frances Converse Massey

Opposite:
Untitled. American. 1898. Lithographic poster, $26\frac{5}{8} \times 17$". Library of Congress

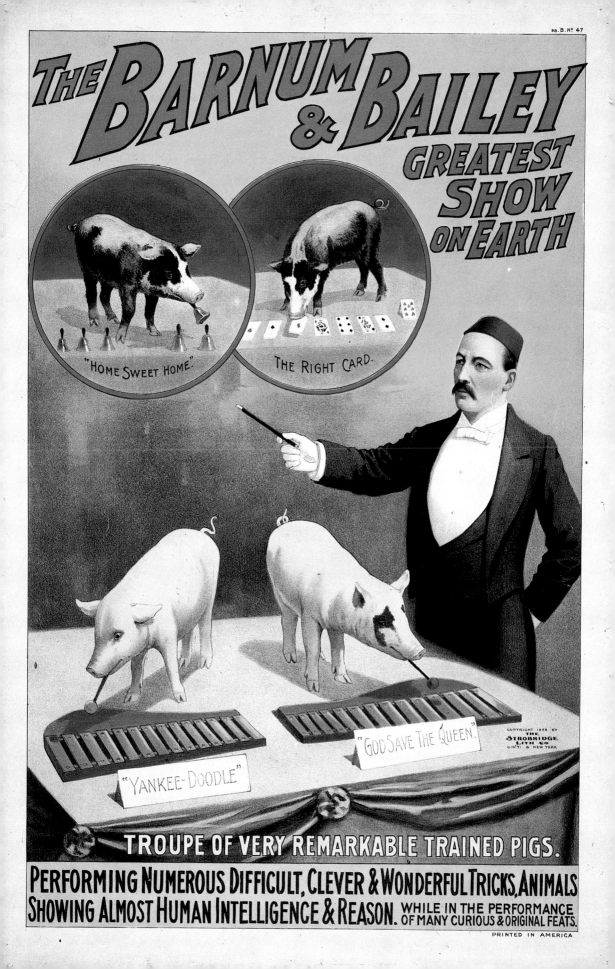

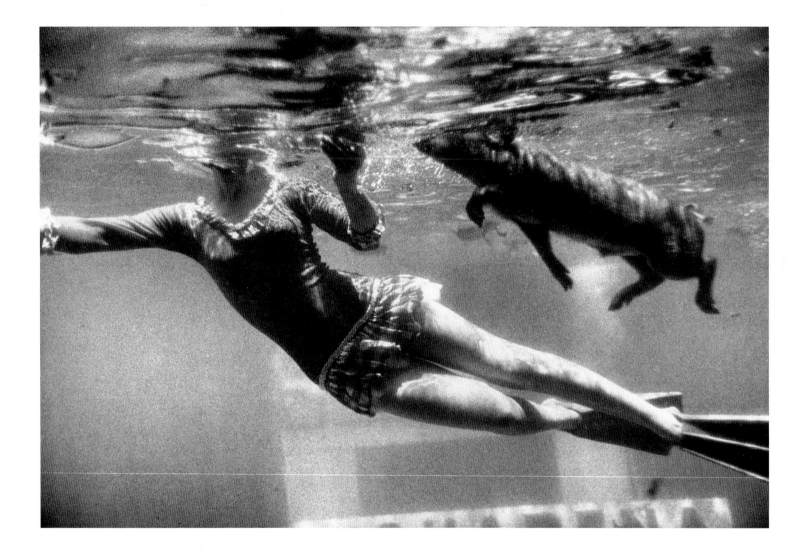

Garry Winogrand (American). *San Marcos, Texas.* 1964. Gelatin-silver print.
Courtesy Fraenkel Gallery, San Francisco, and The Estate of Garry Winogrand

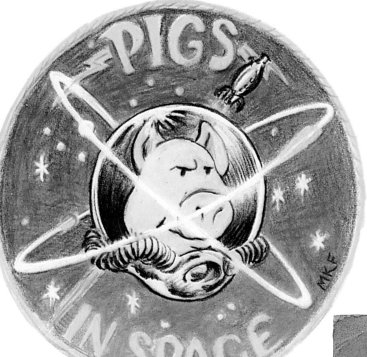

Michael K. Frith. *Pigs in Space.* Alternate logo for a regular segment on *The Muppet Show.* 1975. Colored pencil on tracing paper, 4″ in diameter. © Henson Associates, Inc.

"The time has come," the Walrus said,
"To talk of many things:
Of shoes—and ships—and sealing-wax—
Of cabbages—and kings—
And why the sea is boiling hot—
And whether pigs have wings."

From "The Walrus and the Carpenter," by Lewis Carroll

Postcard. European. Photographic montage. c. 1910. Collection Frances Converse Massey

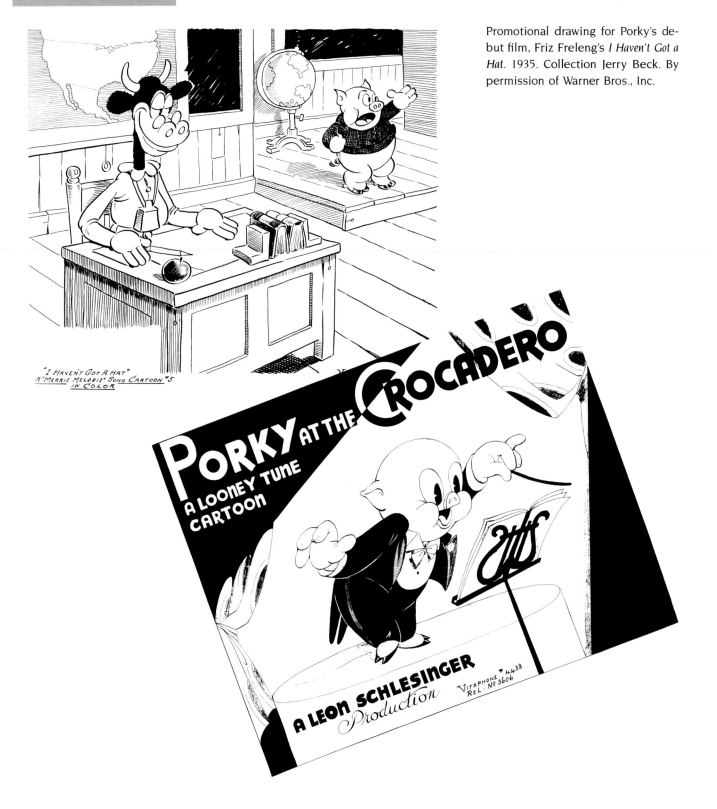

Promotional drawing for Porky's debut film, Friz Freleng's *I Haven't Got a Hat*. 1935. Collection Jerry Beck. By permission of Warner Bros., Inc.

Promotional drawing for Frank Tashlin's *Porky at the Crocadero*, 1938. Collection Jerry Beck. By permission of Warner Bros., Inc.

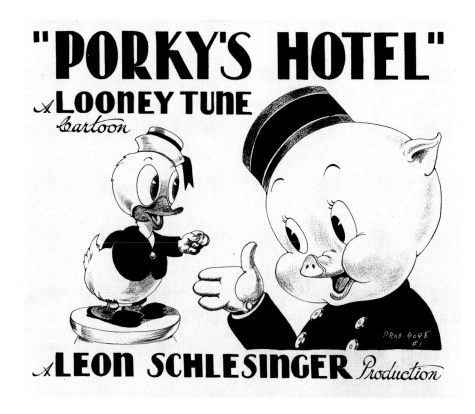

Promotional drawing for Bob Clampett's *Porky's Hotel*, 1939. Collection Jerry Beck. By permission of Warner Bros., Inc.

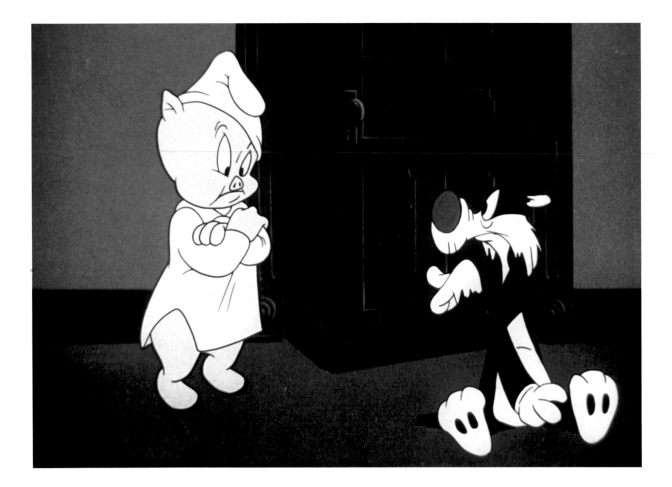

Cel and background of Porky and Sylvester from Chuck Jones's *Scaredy Cat*, 1948. Courtesy Sammis Publishing Corp. By permission of Warner Bros., Inc.

Porky Pig™ *is a mild-mannered and amiable fellow who made his first appearance in a 1935 Warner Bros. animated film called* I Haven't Got a Hat, *which featured a group of animals as small-town school friends. The director of the film, Friz Freleng, says he based Porky on a chubby childhood friend. Porky's distinctive characteristic was his stammer. His voice was first supplied by an extra named Joe Dougherty, who actually stuttered, but Dougherty's delivery was too uneven for the sound editors to work with. Porky's voice was subsequently dubbed by Mel Blanc, who kept the stammer and used it for comic effect.*

Porky emerged from the gang in I Haven't Got a Hat *to become the first star of the Warner Bros. Looney Tunes*™ *series. By the late 1930s, at the hands of a succession of animators, notably Tex Avery and Bob Clampett, Porky evolved from a somewhat unappealing adolescent into a more soft-featured, bouncy, cute adult. He was timid and a bit slow-witted—not characteristics one normally associates with pigs. He acquired a girlfriend, Petunia Pig*™, *and a persona as the nervous foil for more aggressive Looney Tunes characters like Daffy Duck*™. *By the mid-1940s, Porky was no longer the series' biggest star, although he remained active in the Warner Bros. stable. Chuck Jones, who created, directed, and produced many of the films from that period, says Porky was "pushed back because he wasn't very interesting. But he wasn't interesting because we didn't make him very interesting. You can hardly blame it on somebody else."*

While Porky's star waned in comparison to other Looney Tunes characters such as Sylvester or Tweety, and above all Bugs Bunny™, *he nonetheless appeared in 163 cartoons. Although Porky retired in 1965, he was urged to make a comeback appearance in the 1980 cartoon* Duck Rogers and the Return of the 24½ Century. *Porky's films are rerun regularly on Saturday-morning television and are screened and analyzed at film schools and film festivals. Round, pink, and good-natured, Porky has become an American icon.*

PART TWO: PIGS IN CLOVER

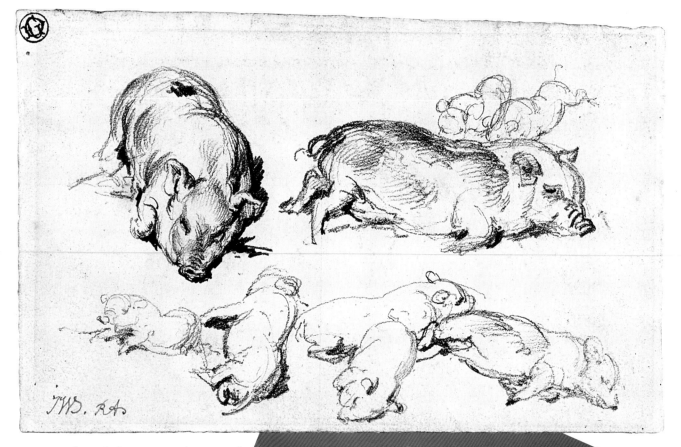

James Ward (English). *Pigs.* No date. Pencil, 5 × 8″. Henry E. Huntington Library and Art Gallery, San Marino, California

David Alvarez (American). *Sow and Piglets.* 1985. Cottonwood, paint, and rope. Sow: 24 × 41 × 20″; piglets: 11 × 14 × 8″. Courtesy Davis Mather Folk Art Gallery, Santa Fe, New Mexico

Opposite: Snowdon. *Lynchett's Princess.* 1990. Courtesy of *Vogue* U.K.

The princess is a Tamworth breed champion who was shampooed, rubbed with baby oil, and sprinkled with powdery sawdust before sitting for her portrait.

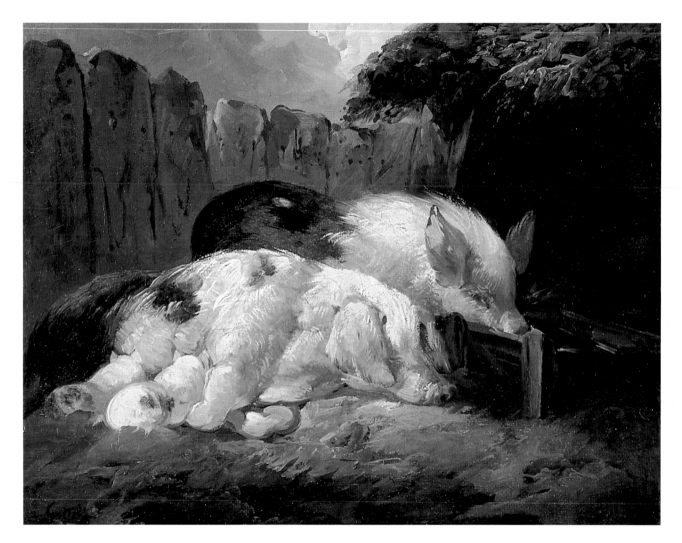

George Morland (English). *Pigs and Piglets in a Sty*. c. 1800. Oil on canvas, 9½ × 12″. Virginia Museum of Fine Arts, Richmond. The Paul Mellon Collection

Two of the most renowned painters of pigs were the English brothers-in-law George Morland and James Ward. George Morland was born in London in 1763, the son and grandson of successful commercial artists. He was prolific in work and profligate in life. A heavy drinker, Morland fraternized with jockeys, prizefighters, and pawnbrokers. Because of gambling losses, he barely avoided debtors' prison. Although Morland lived to the age of only thirty-nine, he produced more than four thousand paintings and drawings. His self-chosen epitaph was, "Here lies a drunken dog."

Morland was among the first painters of rural scenes to make pigs the focus of his work. One critic wrote that Morland comes "very close to the heart of common things," especially in "the piggishness of his pigs."

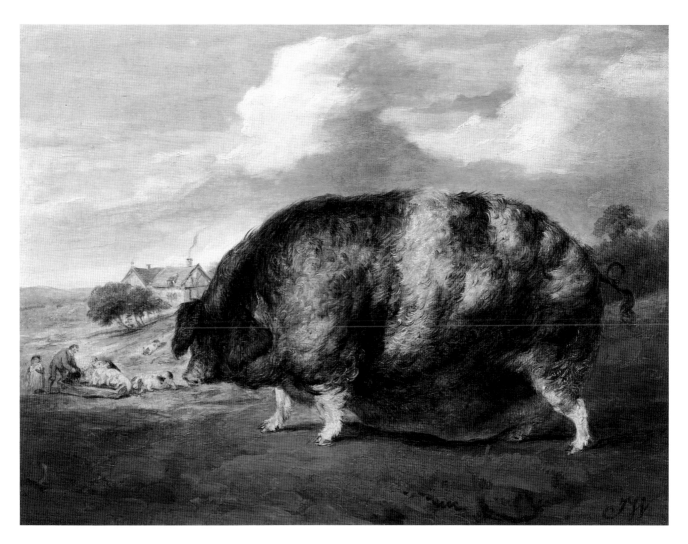

James Ward. *A Gloucester Old Spot.* c. 1800–1805. Oil on panel, 11¾ × 15″. Courtesy Paul Mellon Collection, Upperville, Virginia

James Ward was born in London in 1769. His older brother, William, was an engraver, and James was apprenticed to the same trade at the age of eleven or twelve. William Ward married George Morland's sister, and Morland was married to a sister of the Wards'. James Ward showed an immediate aptitude for drawing. Under the tutelage of Morland he also learned mezzotint engraving and became mezzotint engraver for the Prince of Wales. Following Morland's lead, he began to specialize in animals. As Morland's fortunes declined, Ward's rose. He was commissioned in 1798 by the Agricultural Society to produce a series of paintings of all breeds of farm animals, but the project was left unfinished in 1805 when funds ran out. Ward received many other commissions from animal owners to paint portraits of their prized creatures. He died old and successful in London in 1859.

Weathervane.
American. c. 1880. Molded copper with gilt, 20 × 35 × 6½".
Courtesy Hirschl & Adler Galleries, Inc.,
New York

Pottery plate. Saturday Evening Girls Pottery. Boston. Four-color incised decoration of repeating pigs with central monogram of H. O. S., for Helen Osborne Storrow. Marked on reverse: SEG, 414-12-10, F. R. 8¼" in diameter. Collection Marilee B. Meyer

Helen Osborne Storrow was a Boston philanthropist who, in the first half of the twentieth century, financed a pottery club to teach immigrant women a trade. The pottery was sold through catalogues and at department stores. The markings on the back of the plate indicate that it was made by the Saturday Evening Girls in December 1910; F. R. was probably the artist's monogram.

Weathervane. American. 1920–30. Sheet iron, 17 × 42". Private Collection

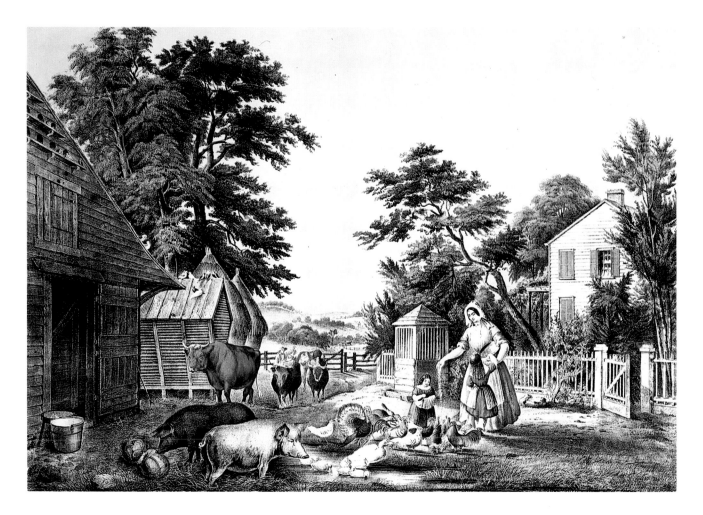

Currier & Ives (American). *American Farm Scene.* Second half of the nineteenth century. Lithograph

You might have known it was Sunday if you had only waked up in the farmyard. The cocks and hens seemed to know it, and made only crooning subdued noises: the very bulldog looked less savage, as if he would have been satisfied with a smaller bite than usual. The sunshine seemed to call all things to rest and not to labour; it was asleep itself on the moss-grown cow shed; on the group of white ducks nestling together with their bills tucked under their wings; on the old black sow stretched languidly on the straw, while her largest young one found an excellent spring bed on his mother's fat ribs.

From Adam Bede, *by George Eliot*

Helen Levitt (American). *New Hampshire*. 1986. Gelatin-silver print, 7¼ × 11³⁄₁₆″. Laurence Miller Gallery, New York

Felipe Archuleta (American). Untitled. 1970. Cottonwood, paint, and rope. Sow: 28 × 51 × 15"; piglets: 9½ × 17½ × 10". Davis Mather Folk Art Gallery, Santa Fe, New Mexico

Miles Carpenter (American). *Sow and Seven Piglets*. 1973. Painted wood, 7½ × 18 × 11". Museum of International Folk Art, a unit of the Museum of New Mexico, Santa Fe. Purchased with the aid of funds from the National Endowment for the Arts and the International Folk Art Foundation

WALLOWING

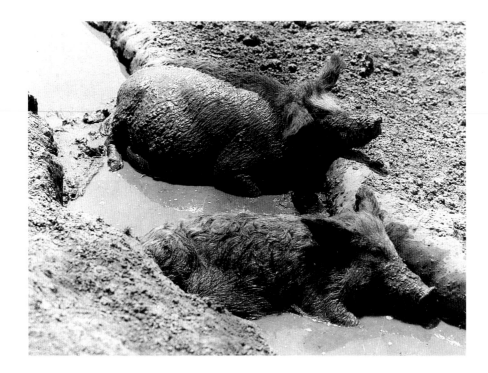

Pigs grunt in a wet wallow-bath, and smile as they snort and dream. They dream of the acorned swill of the world, the rooting for pig-fruit, the bagpipe dugs of the mother sow, the squeal and snuffle of yesses of the women pigs in rut. They mud-bask and snout in the pig-loving sun; their tails curl; they rollick and slobber and snore to deep, smug, after-swill sleep.

From Under Milk Wood, *by Dylan Thomas*

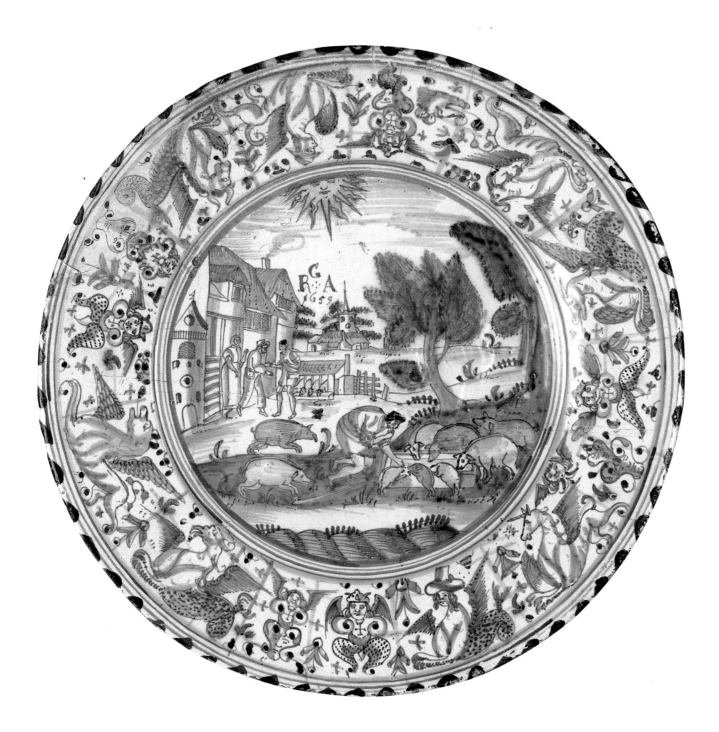

Platter painted with the scene of the Prodigal Son as a swineherd. London, possibly Southwark. 1659. Tin-glazed earthenware (delftware). Initialed RAG on front and WF on reverse. 23½″ in diameter. Reproduced by Courtesy of the Trustees of the British Museum

The initials RAG are probably those of the husband and wife for whom the dish was made; the initials WF are possibly those of the painter.

The story of the Prodigal Son, who squandered his inheritance, was a popular subject for many artists. The depth of his degradation is described in Luke 15:15–16: "And he went and joined himself to a citizen of that country; and he sent him into his fields to feed swine. And he would fain have filled his belly with the husks that the swine did eat: and no man gave unto him."

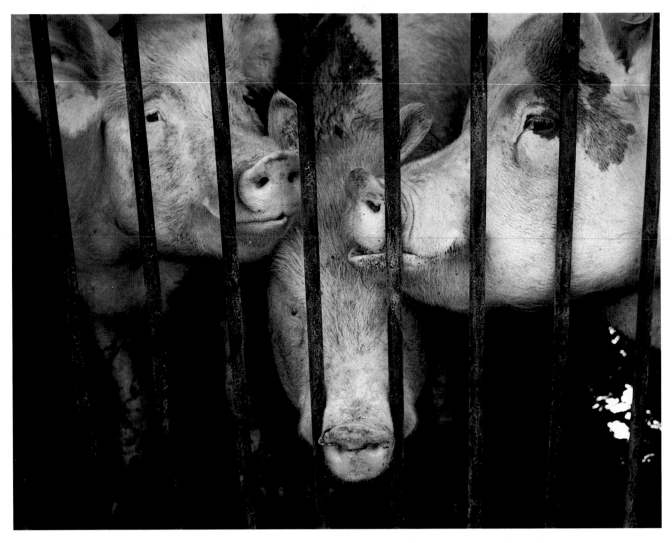

Jerome Liebling (American). *Northampton Farm Series: Pigs at Fence.* 1986. Kodak C print, 16 × 20″. Collection of the artist

Opposite:
The delicate scent of black truffles is particularly attractive to sows. Found primarily in the southwest of France, truffles grow underground in the root systems of oak trees. A farmer searching for a good hunting partner would go to the barnyard with a small piece of a fresh truffle in his pocket; the first sow to poke at his pantleg got the job. Although chemists have identified the elements of the truffle's aroma, no one is absolutely sure what makes it so attractive to pigs. What is unmistakable is the pleasure they take in rooting for anything.

"The Pigs and the Charcoal-Burner"

The old Pig said to the little pigs,
"In the forest is truffles and mast,
Follow me then, all ye little pigs,
Follow me fast!"

The Charcoal-burner sat in the shade
With his chin on his thumb,
And saw the big Pig and the little pigs
Chuffling come.

He watched 'neath a green and giant bough,
And the pigs in the ground
Made a wonderful grisling and gruzzling
And greedy sound.

And when, full-fed, they were gone, and Night
Walked her starry ways,
He stared with his cheeks in his hands
At his sullen blaze.

Walter de la Mare

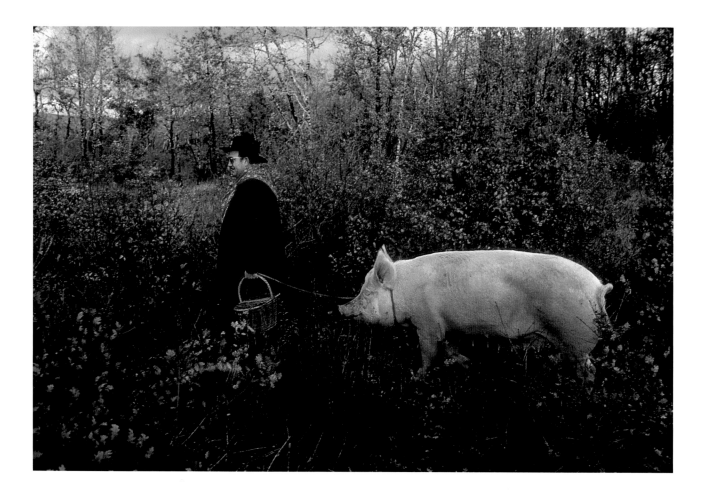

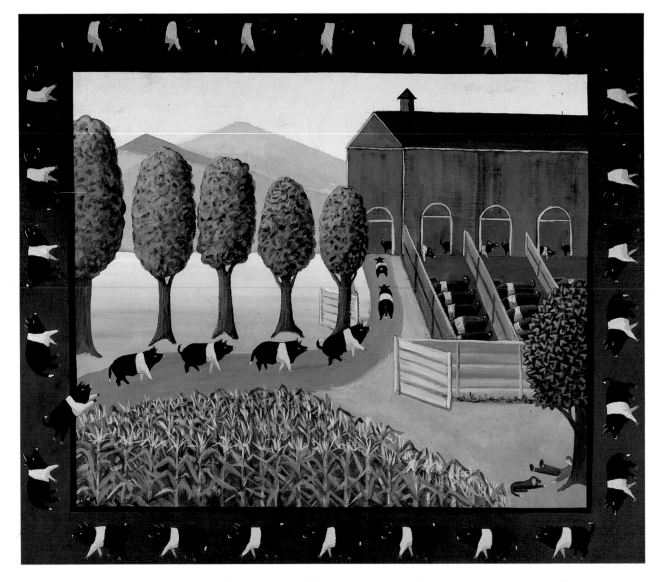

Barbara Moment (American). *Bringing the Pigs In*. 1983. Oil on canvas, 24 × 28″. Courtesy Jay Johnson Gallery, New York

Reflect, reader, how it would be with you if you had an immensely long, barrel-shaped and capacious body carried on four very short legs: if you had a nose (or snout) especially constructed and designed to go to the root of matters: if you had a mouth of peculiar capacity, stretching almost from ear to ear. . . . Would you not enjoy your food even more than you do now? Would you not grunt, and even slightly squeal, with the excruciating ecstasy of creamy, rich barley-meal, as it entered your long and wide mouth, gurgled in your roomy throat and flowed on into that vast stomach forever clamouring to be soothed?

From "Reflections on Bacon," by John Beresford

Wallace Kirkpatrick (American). c. 1880. Stoneware flask: incised and salt-glazed, 8″ long. Private Collection

The flask is incised with a pattern of lines that represent railroad routes and key place names in the Midwest, including THE MISSISSIPPI RIVER, CINCINNATI/THE PORKOPOLIS, ST. LOUIS/THE FUTURE CAPITAL, *and the legend* FROM THO. GAUBATZ WITH A LITTLE GOOD OLD RYE. *The design, combining corn, pigs, whiskey, and railroads, sums up the foundations of nineteenth-century Midwestern economy.*

The Kirkpatrick family of potters, of Anna, Illinois, made many animals in the late nineteenth century. This pottery pig, filled with whiskey, was probably given out by Tho. Gaubatz as a convention favor.

John Vine (English). 1857. *Three Middle White Sows in a Sty.* Oil on millboard, 19½ × 25½″. Courtesy Iona Antiques, London

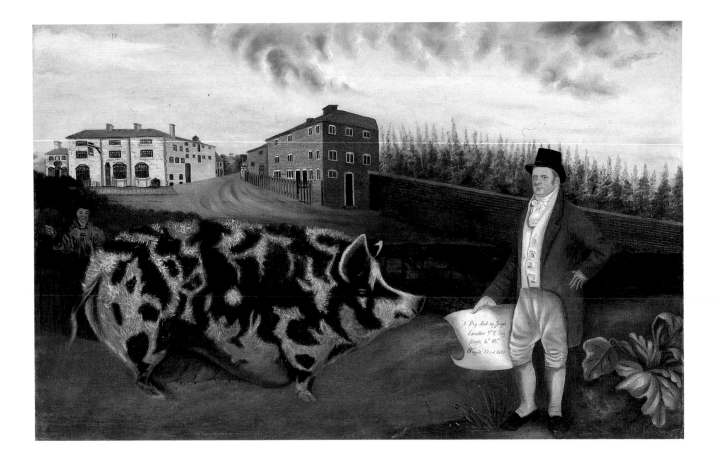

Artist unknown. *Joseph Lawton's Midland Plum Pudding Pig at Little Haywood*. Staffordshire. Early nineteenth century. Oil on canvas, 26½ × 42″. Inscribed on the scroll: BRED BY JOSEPH LAWTON, 9 FT. 8 INS. LONG. HEIGHT 4 FEET 8½ INS. WEIGHT 12 CWT 66 LB. Courtesy Rutland Gallery, London

Lawton's pig was reputed to be the largest ever bred in the British Isles as of about 1774. The artist who painted him several decades later apparently was working from memory or a previous painting or sketch. Nineteenth-century Englishmen prized animals that seem obese and distorted by today's standards. Gentleman farmers competed to raise enormous beasts whose legs could barely support their body weight.

Feeding Pigs. Sample from a banknote engraving scrapbook. American. c. 1840–50. The Connecticut Historical Society, Hartford

Until 1863 individual American banks could print their own currency backed by whatever assets they held. These bank notes varied in size, design, and ease of redemption. Repeated bank failures led to the National Bank Act of 1863, which standardized the currency and centralized its control.

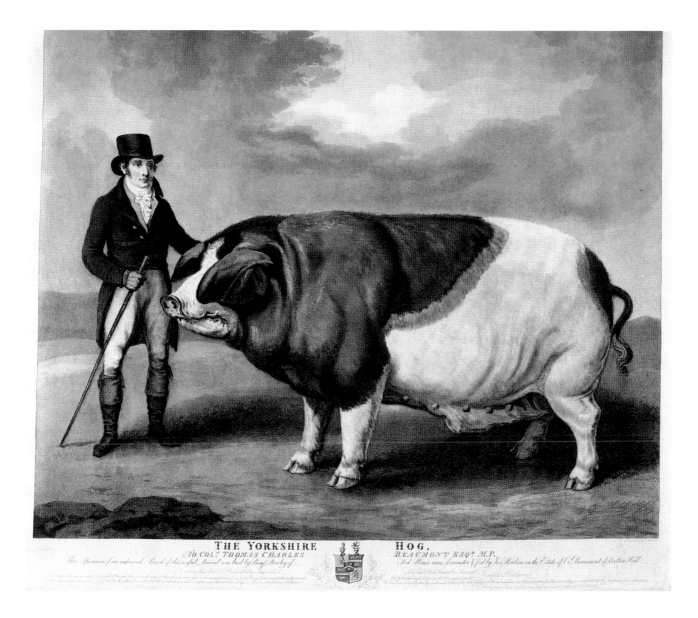

THE YORKSHIRE HOG,
To Col.^l THOMAS CHARLES BEAUMONT ESQ.^r M.P.

The Yorkshire Hog. Engraved by R. Pollard. London, 1809. Aquatint with some etching and mezzotint, 16¾ × 20½″. Collection Rothamsted Experimental Station Library, Harpenden, England

The aquatint is accompanied by the following notice:

The Yorkshire hog, to Coln. Thomas Charles Beaumont Esqr. M.P. This specimen of an improved breed of this useful animal was bred by Benjn. Rowley of Red House near Doncaster & fed by Josh. Hudson on the estate of Col. Beaumont of Bretton Hall to whom this print is respectfully inscribed by his obedt. humble servant Joseph Hudson. This stupendous creature for height & length far exceeds any of this species ever yet seen measuring 9′10″ long 8′ round the body stands 12½ hands high 4 years old & weighs 1344 lbs. or 160 stone 8 lb to the stone or 96 st 14 lb to the stone & would feed to a much greater weight were he not raised up so often to exhibit his stature. He has been view'd by the Agricultural Society & the best judges with astonishment & excited the public curiosity so much that the proprietor for admittion money to see him in 3 years has received near 3,000 pounds!!!

Attributed to James Clark (English). *Three Prize Pigs in a Pen*. c. 1865. Oil on canvas, 18 × 24″. Inscribed with the legend FED & BRED BY SIR J. B. MILL BART AGE 7 MONTHS 4 DAYS FIRST PRIZE £40 SILVER MEDAL. Courtesy Iona Antiques, London

Pigs are very beautiful animals. Those who think otherwise are those who do not look at anything with their own eyes, but only through other people's eyeglasses. The actual lines of a pig (I mean of a really fat pig) are among the loveliest and most luxuriant in nature; the pig has the same great curves, swift and yet heavy, which we see in rushing water or in rolling clouds. . . . He has that fuller, subtler and more universal kind of shapeliness which the unthinking (gazing at pigs and distinguished journalists) mistake for a mere absence of shape. For fatness itself is a valuable quality. While it creates admiration in the onlookers, it creates modesty in the possessor. If there is anything on which I differ from the monastic institutions of the past, it is that they sometimes sought to achieve humility by means of emaciation. It may be that the thin monks were holy, but I am sure it was the fat monks who were humble. Falstaff said that to be fat is not to be hated, but it certainly is to be laughed at, and that is a more wholesome experience for the soul of man.

From "The Uses of Diversity," by G. K. Chesterton

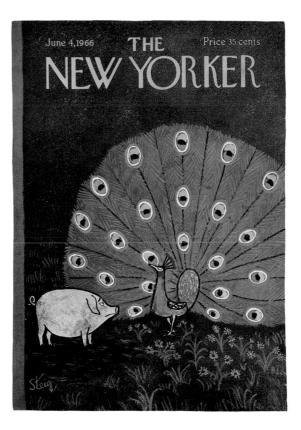

Cover drawing by Wm. Steig. © 1966 The New Yorker
Magazine, Inc.

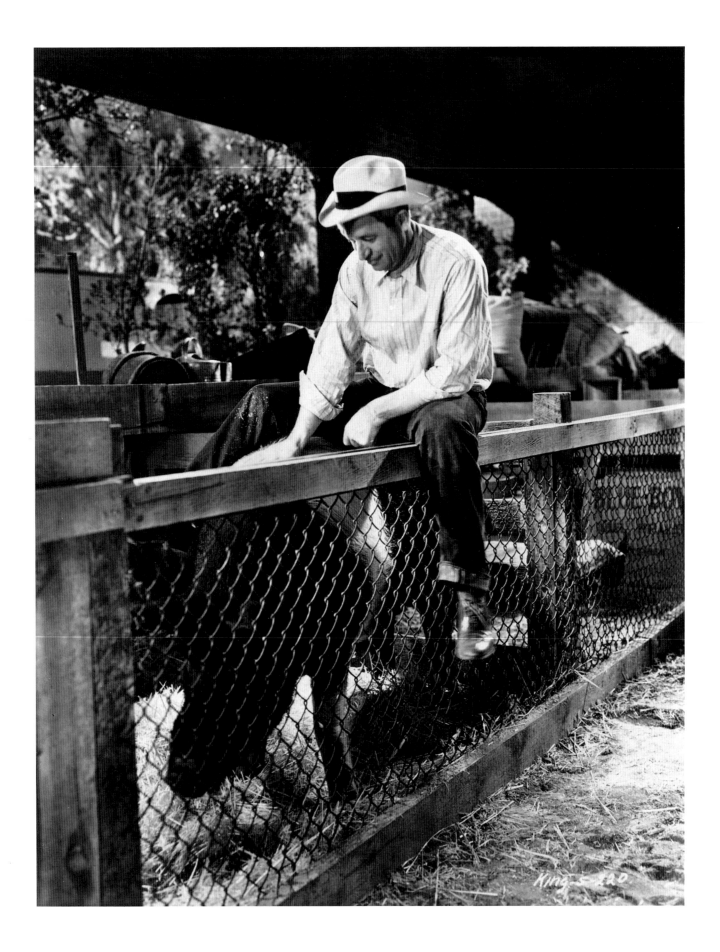

Rehearsal for hog-calling contest in Long Beach, California. September 13, 1941

Garry Winogrand. *Fort Worth, Texas.* 1974. Gelatin-silver print. Courtesy Fraenkel Gallery, San Francisco, and The Estate of Garry Winogrand

Opposite:
Still from 1933 movie *State Fair*, starring Will Rogers and Blue Boy. The Museum of Modern Art/Film Stills Archive

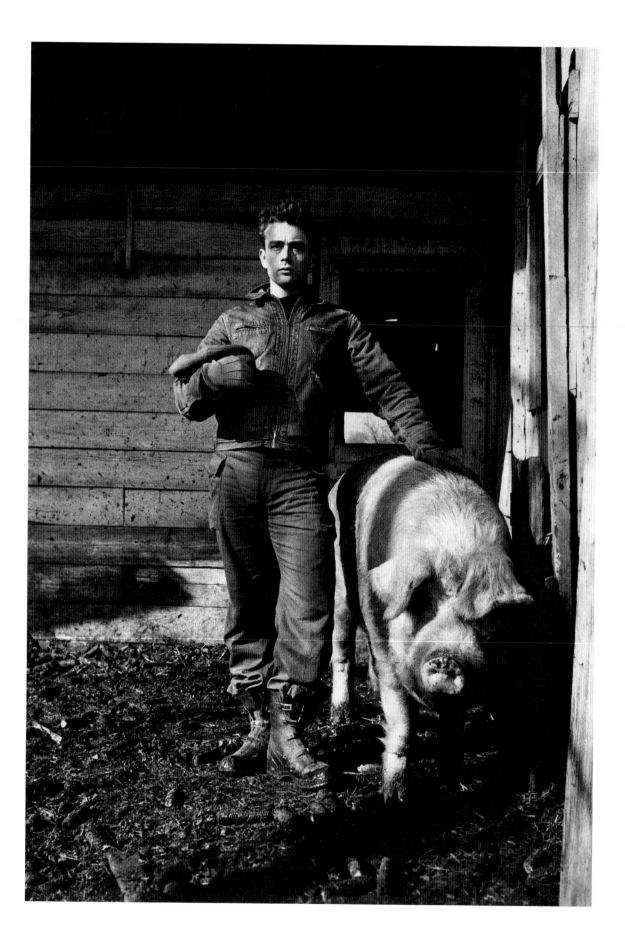

Opposite: James Dean went home to Indiana for a visit in February 1955.
The hog lived on Dean's uncle's farm.

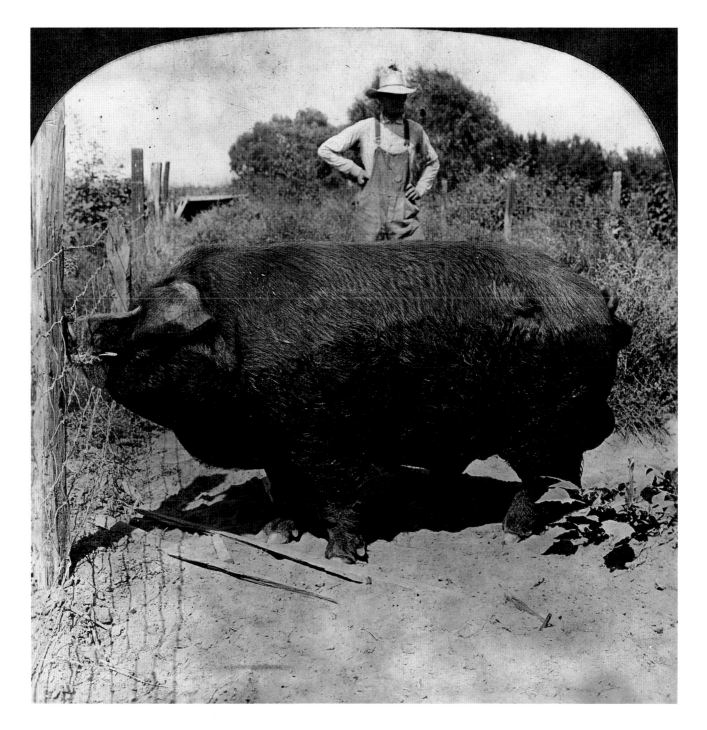

Prize hog on a Midwestern farm. 1923

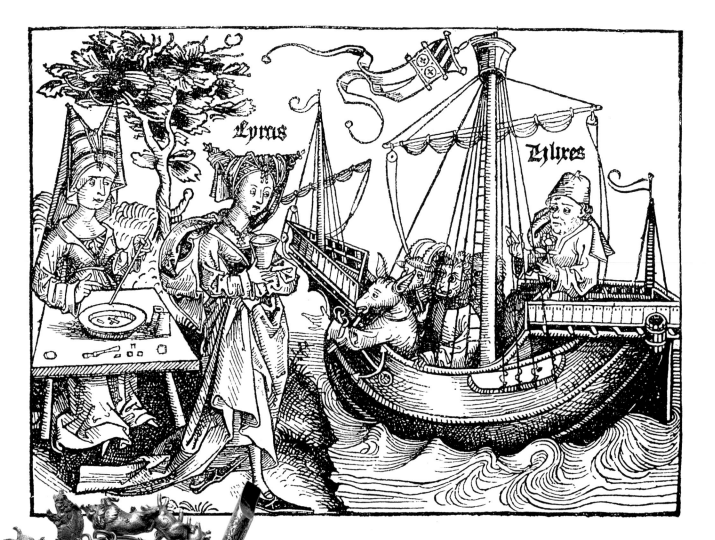

Circe and Odysseus. Illustration from Homer's *Odyssey*. German. 1493. Woodcut

Among the many adventures of Odysseus and his men on their long journey home from Troy was their encounter with the enchantress Circe. To keep her lover Odysseus and his men captive on her island, she turned the crew into swine for a year. The transformation seemed to do no harm; in fact, when restored to human form, the men were younger, taller, and more handsome than before. Circe has become a symbol of the wily seductress who captivates and collects men.

Charm bracelet with twenty-nine animals. French. Early twentieth century. Silver. Collection Marcia Carter

This bracelet is said to have been designed and owned by a French noblewoman with an active romantic life. Although twenty-six of the twenty-nine charms are pigs, no two are alike. Each is inscribed with initials or a name, allegedly to commemorate the lady's lovers.

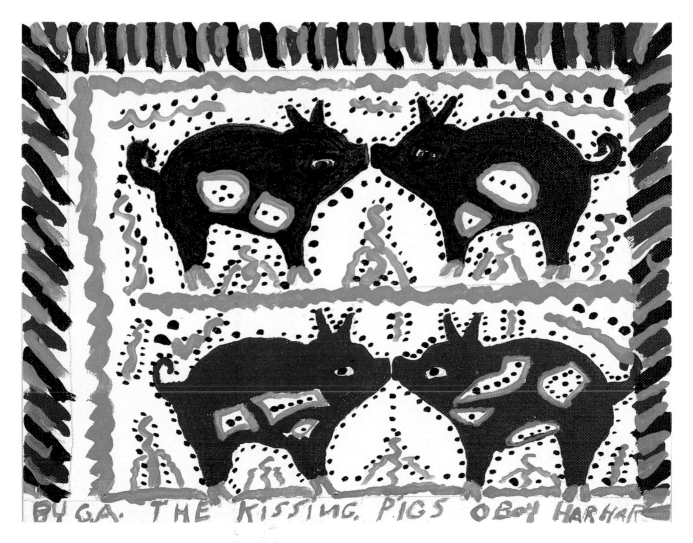

George Andrews (American). *The Kissing Pigs O Boy Har Har*. 1970–89. Oil on canvasboard, 12 × 16″. Collection of the artist, courtesy Memphis Brooks Museum of Art, Tennessee

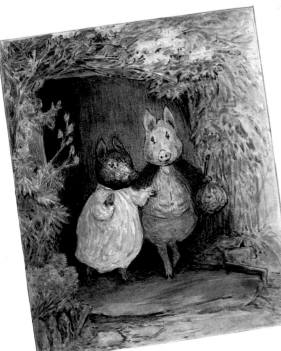

Beatrix Potter. Illustration from *The Tale of Pigling Bland*. Copyright © Frederick Warne & Co., 1913, 1987. Reproduced by permission of Frederick Warne

Graham Greene once wrote that Beatrix Potter "was the first to throw any real light on the Love Life of the Pig, and this she did with a delicacy and a psychological insight that recall [Jane] Austen. She drew for the first time in literature the feminine pig." Perhaps Miss Potter wrote so movingly about the romance of Pigling Bland and his beloved Pig-Wig because, at the same time, she was planning her own marriage.

Untitled. c. 1890. Continental majolica, 7 × 4 × 4″. Collection Karmason-Stacke

Maurice Sendak (American). Untitled. 1979. Pencil on paper, 8¾ × 8⅛″ (framed). Collection Frances Converse Massey

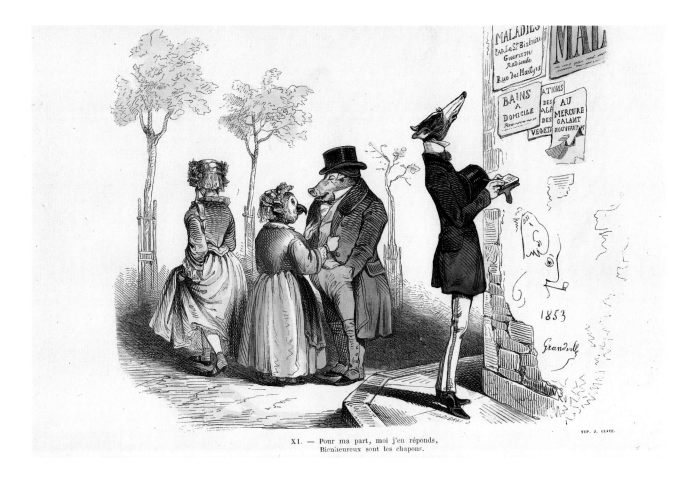

XI. — Pour ma part, moi j'en réponds,
Bienheureux sont les chapons.

J. -I. Grandville. Illustrations from *Metamorphoses du Jour*, Paris, Gustave Havard Libraire, 1854. Print Collection, Miriam and Ira D. Wallach Division of Art, Prints, and Photographs, The New York Public Library. Astor, Lenox and Tilden Foundations

LVI.

Écoute donc, mon petit lapin, je suis bien aimable..... va. . .

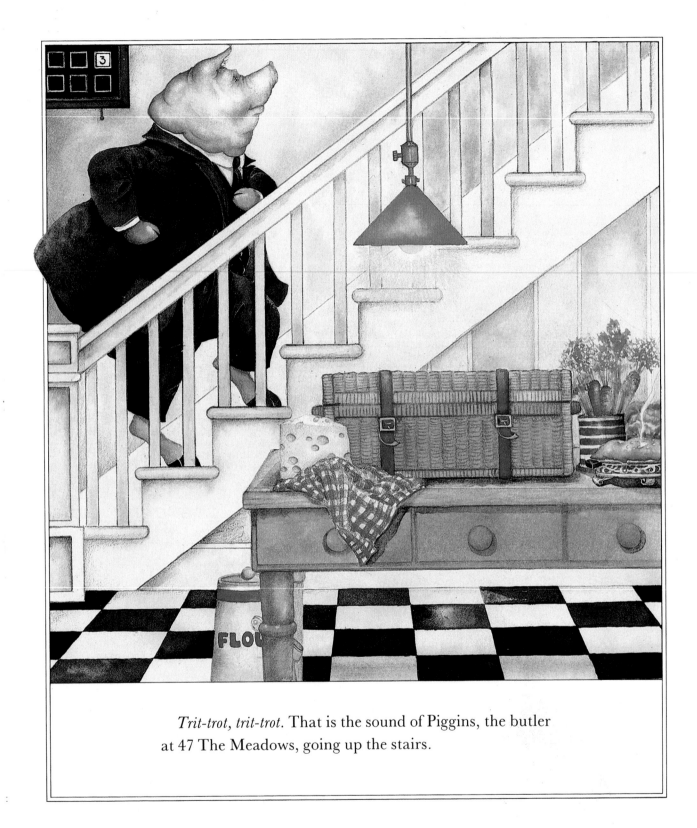

Trit-trot, trit-trot. That is the sound of Piggins, the butler at 47 The Meadows, going up the stairs.

Kurt Wiese. Illustrations from *Freddy Goes Camping*, by Walter R. Brooks. Copyright © 1948 by Walter R. Brooks. Copyright renewed 1975 by Walter R. Brooks. Reprinted by permission of Alfred A. Knopf, Inc.

Freddy is the hero of a series of twenty-six children's books written by Brooks between 1929 and his death in 1958. Many of his readers remain so loyal that, as adults, they have formed The Friends of Freddy, a fan club complete with newspaper, annual convention, and computer mailbox.

Opposite:
Excerpts from *Picnic with Piggins*, text copyright © 1988 by Jane Yolen and illustration copyright © 1988 by Jane Dyer, reprinted by permission of Harcourt Brace Jovanovich and Curtis Brown, Ltd.

Five minutes later, Freddy came downstairs.

There was once a pig named Roland, who played the
lute and sang so sweetly that his friends never had enough
of listening to him. He was a natural musician—from his
hoofs to his snout.

It so happened that he also knew a lot of good jokes and
riddles, and could stand balanced on his front legs.

Fritz Eichenberg. Illustration from *Padre Porko*, by Robert Davis. Copyright 1939 by Robert Davis.
Reprinted by permission of Holiday House

Padre Porko, the wise, benevolent pig in Robert Davis's stories, is based loosely on folk tales that Mr. Davis heard in Spain in the late 1930s.

Next morning, Wilbur arose and stood beneath the web. He breathed the morning air into his lungs. Drops of dew, catching the sun, made the web stand out clearly. When Lurvy arrived with breakfast, there was the handsome pig, and over him, woven neatly in block letters, was the word TERRIFIC. Another miracle.

Lurvy rushed and called Mr. Zuckerman. Mr. Zuckerman rushed and called Mrs. Zuckerman. Mrs. Zuckerman ran to the phone and called the Arables. The Arables climbed into their truck and hurried over. Everybody stood at the pigpen and stared at the web and read the word, over and over, while Wilbur, who really felt terrific, stood quietly swelling out his chest and swinging his snout from side to side.

"Terrific!" breathed Zuckerman, in joyful admiration. "Edith, you better phone the reporter on the Weekly Chronicle *and tell him what has happened. He will want to know about this. He may want to bring a photographer. There isn't a pig in the whole state that is as terrific as our pig."*

From Charlotte's Web, *by E. B. White*

PART THREE: TO MARKET, TO MARKET

Opposite:
John Cisney (American). *Pig in a Pan*. 1990. Carved and painted wood, $25 \times 18 \times 2\frac{1}{2}''$. Courtesy Jay Johnson Gallery

Pinkee—the Farmer. Japanese. 1950s. Battery-operated toy: tin litho, $4 \times 11 \times 5''$. Collection Vernon E. Chamberlain

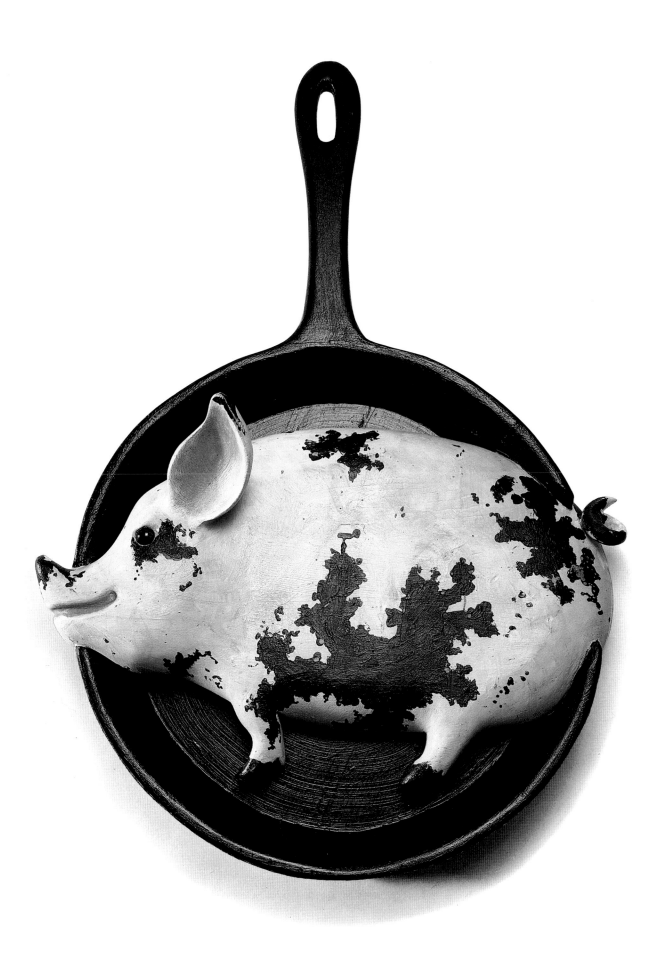

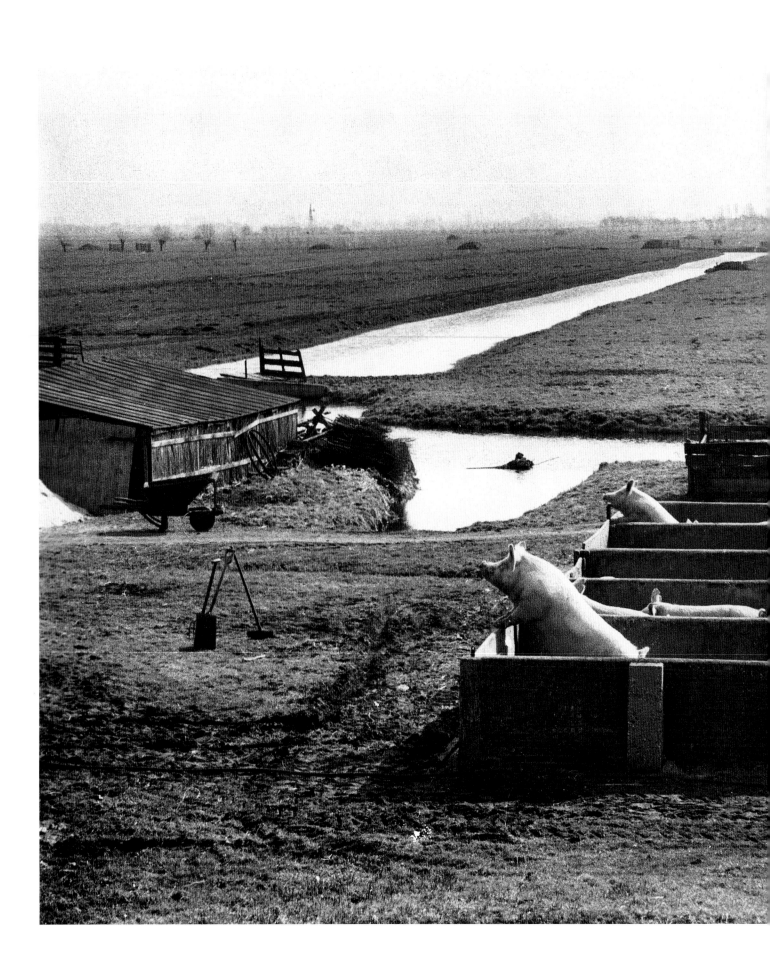

"Animals Are Passing from Our Lives"

It's wonderful how I jog
on four honed-down ivory toes
my massive buttocks slipping
like oiled parts with each light step.

I'm to market. I can smell
the sour, grooved block, I can smell
the blade that opens the hole
and the pudgy white fingers

that shake out the intestines
like a hankie. In my dreams
the snouts drool on the marble,
suffering children, suffering flies,

suffering the consumers
who won't meet their steady eyes
for fear they could see. The boy
who drives me along believes

that any moment I'll fall
on my side and drum my toes
like a typewriter or squeal
and shit like a new housewife

discovering television,
or that I'll turn like a beast
cleverly to hook his teeth
with my teeth. No. Not this pig.

Philip Levine

Henri Cartier-Bresson.
The Netherlands, 1956

99

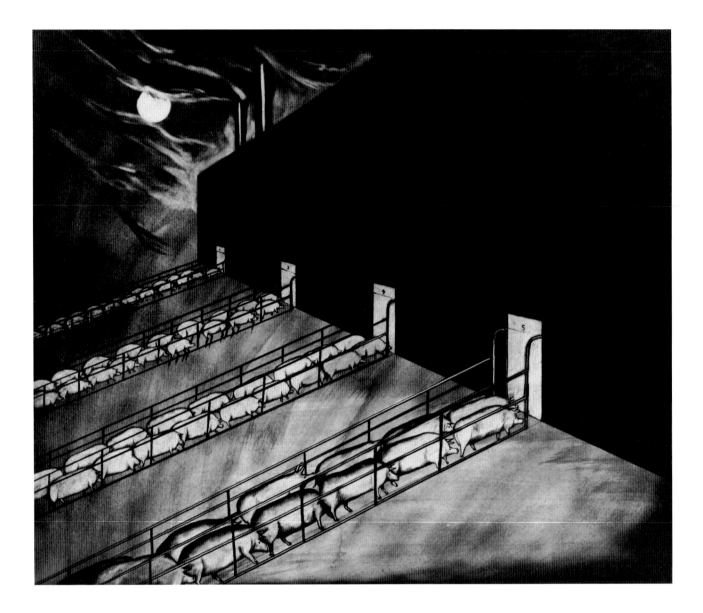

Sue Coe. *Last Bit of Daylight*. 1988. Graphite on paper, 14¾ × 17¾". Porkopolis no. 6. Copyright
© 1988 Sue Coe. Courtesy Galerie St. Etienne, New York

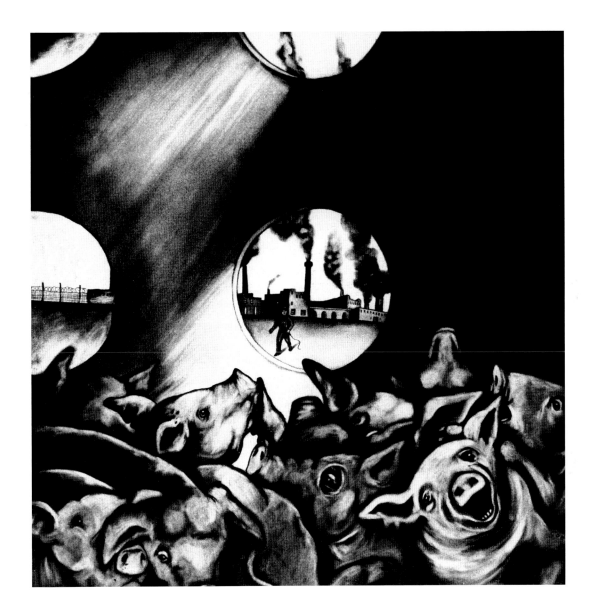

Sue Coe. *In a Pig's Eye*. 1989. Graphite and watercolor on paper, 10⅛ × 10¼". Porkopolis no. 81. Copyright © 1989 Sue Coe. Courtesy Galerie St. Etienne, New York

Sue Coe is a politically engaged artist whose previous work has attacked racism in South Africa and America. Since 1988 she has been working on Porkopolis, a series of more than one hundred graphic works documenting the horrors of the American stock-raising and meat-packing industries. In the tradition of socially committed artists like Honoré Daumier and William Hogarth, Coe conveys her sense of outrage at the mistreatment of animals from birth to death and the dehumanizing impact on everyone who produces or consumes them.

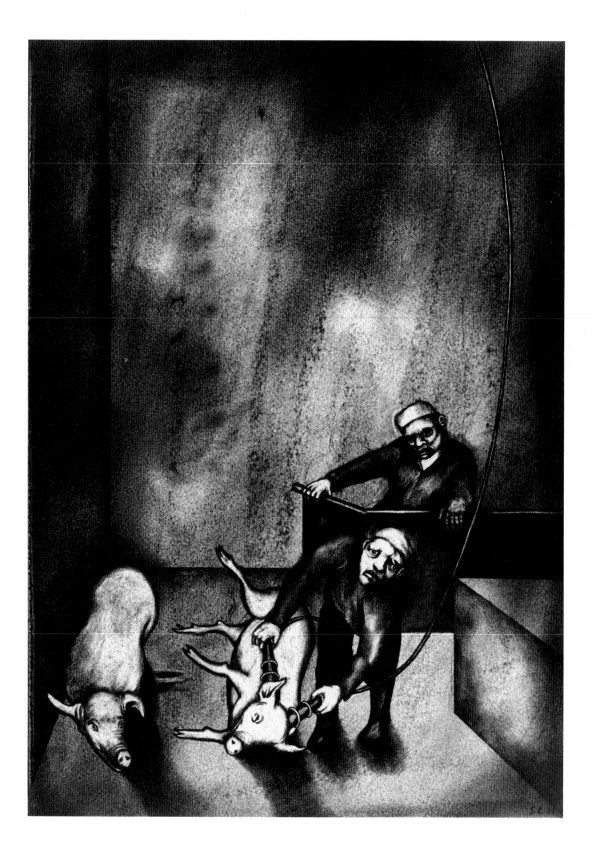

Sue Coe (English). *Electrocution*. 1988. Watercolor and graphite, 29 × 23″. Porkopolis no. 8. Copyright © 1988 Sue Coe. Courtesy Galerie St. Etienne, New York

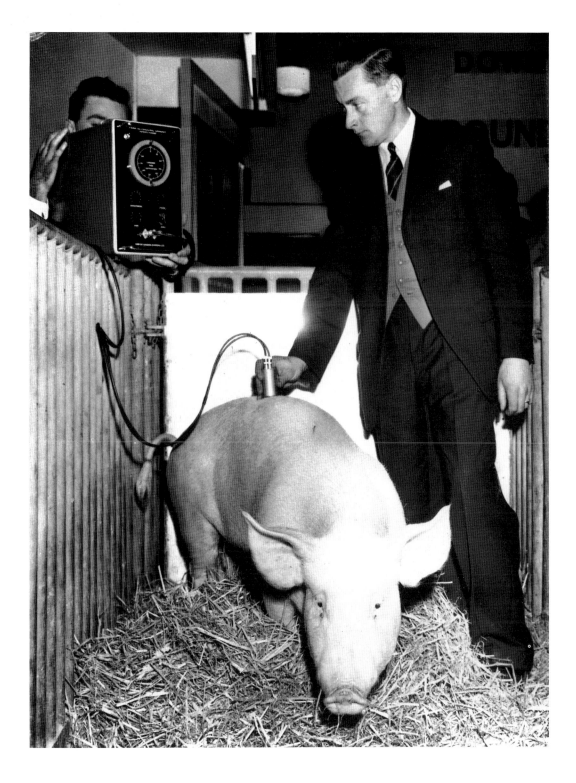

In 1961 a new ultrasonic fat-measuring device was demonstrated at the Royal Smithfield Show at Earls' Court, London. The caption explains that the instrument, which is "based on the same principle as radar, directs sound waves into the porker's body. When these waves strike the division between fat and lean, or between lean meat and bone, signals are recorded on the instrument, showing the depth the waves have traveled."

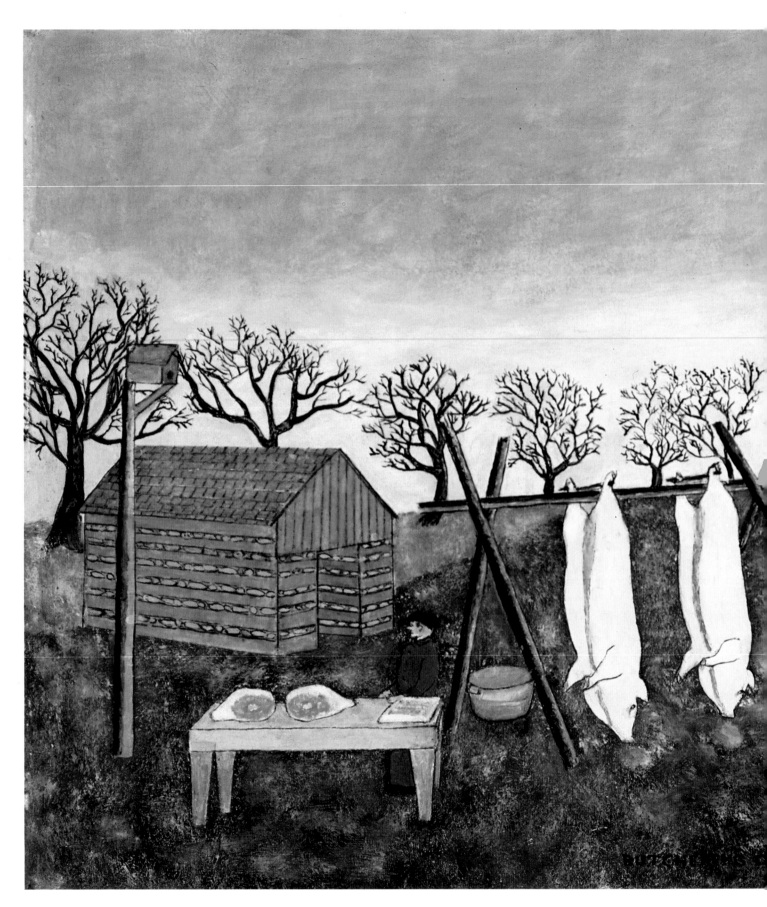

Jennie Cell (American). *Butchering Day*. No date. Oil on fiberboard, 16⅛ × 26½″. National Museum of American Art, Smithsonian Institution. Gift of Mr. and Mrs. James Mundis

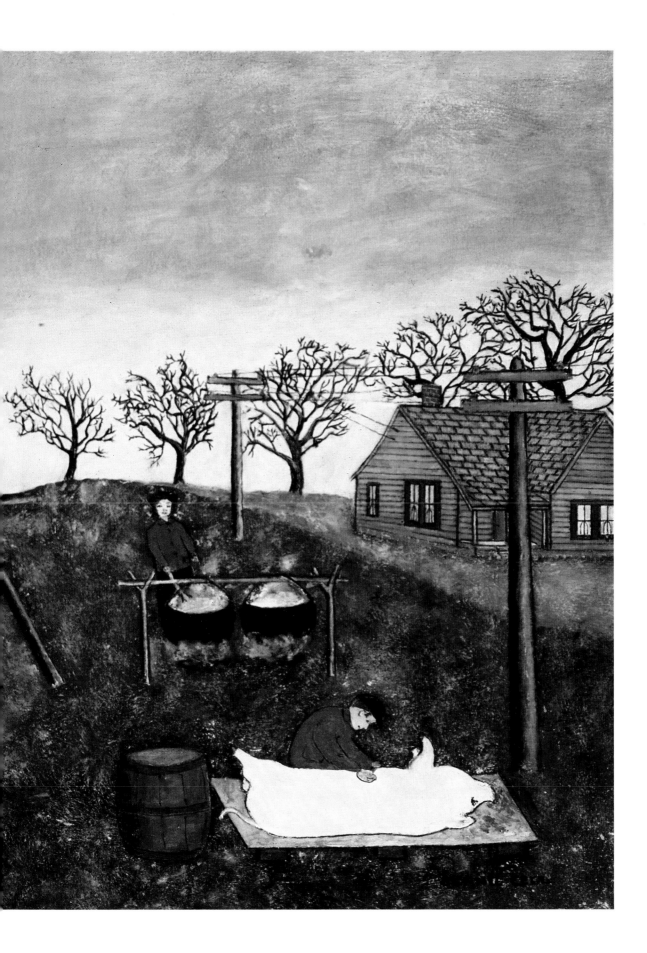

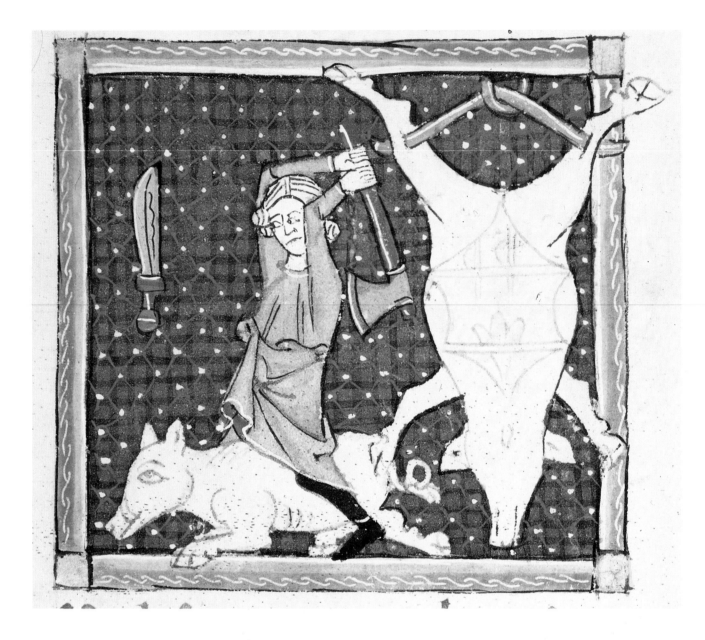

Master Ermengol de Beziers (French). *Pig Sacrifice*. Illustration from *Le Bréviaire d'Amour* (Provençal Codex), Folio 59, December. Thirteenth century. Escorial. Biblioteca Real, Spain

Pig Killing. Illustration from a calendar, December. Flemish. Early sixteenth century. Watercolor. The British Library

106

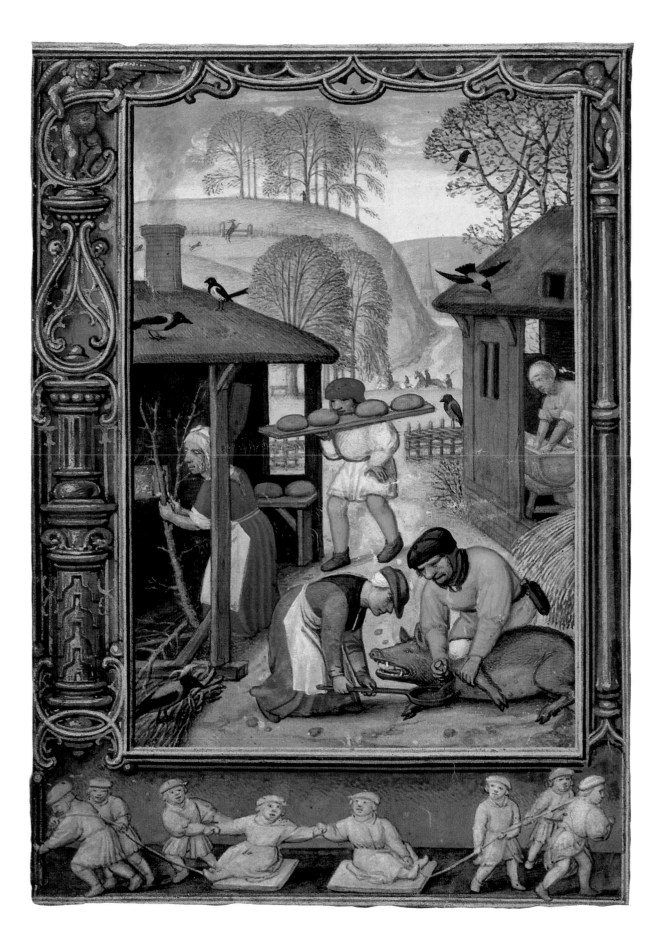

We Recommend Squire's. Butcher-shop display made for John P. Squire & Co., Boston. 1906. Lithograph on tin, 23½ × 19¾". Collection Roi Davis

The Taste Is So Good! Butcher-shop display, probably made in Canton, Ohio, for Decker's Iowana Hams & Bacon. Early 1930s. Papier-mâché with polychrome finish, 7 × 14". Collection Roi Davis

Pinky. Butcher-shop display made for Leo Fuller's Sugar-pact Selected Hams and Bacon, Toronto. 1920. Painted gesso, 13" high. Collection Vernon E. Chamberlain

"The Pig"

The pig, if I am not mistaken,
Supplies us sausage, ham and bacon.
Let others say his heart is big—
I call it stupid of the pig.

Ogden Nash

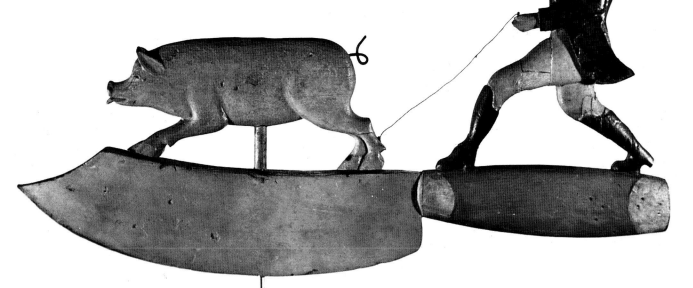

Weathervane. American. c. 1835. Polychrome wood and wire, 31¾″ long.
New Bedford Whaling Museum, Massachusetts

*This weathervane was originally installed on the roof of a slaughterhouse owned by
Captain David West in Fairhaven, Massachusetts.*

It's Duff's. Butcher-shop display made for Duff's Packer, Montreal.
1920s. Plaster, 10 × 16″. Collection Vernon E. Chamberlain

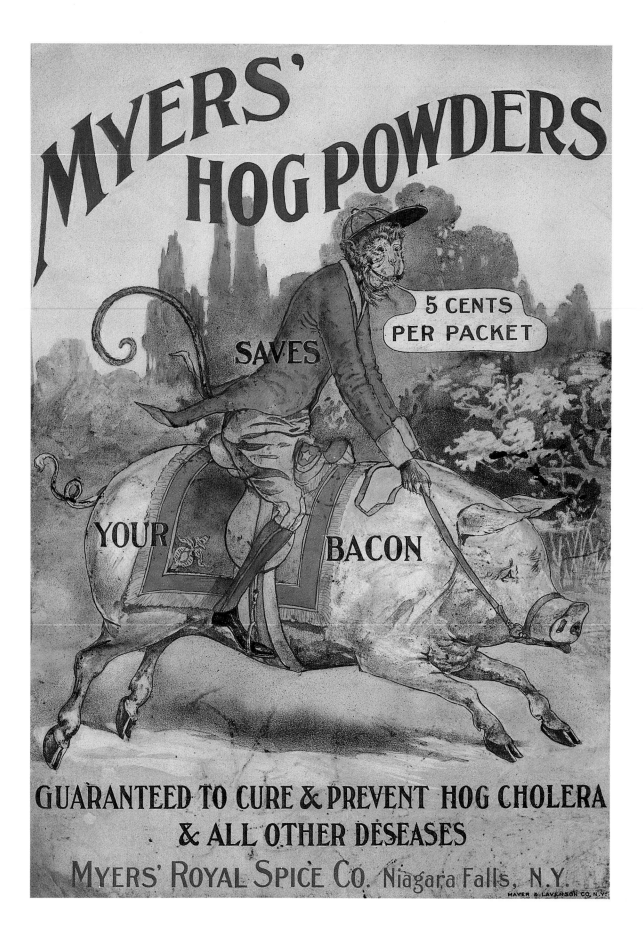

"The Pig"

The pig, if I am not mistaken,
Supplies us sausage, ham and bacon.
Let others say his heart is big—
I call it stupid of the pig.

Ogden Nash

Weathervane. American. c. 1835. Polychrome wood and wire, 31¾" long.
New Bedford Whaling Museum, Massachusetts

*This weathervane was originally installed on the roof of a slaughterhouse owned by
Captain David West in Fairhaven, Massachusetts.*

It's Duff's. Butcher-shop display made for Duff's Packer, Montreal.
1920s. Plaster, 10 × 16". Collection Vernon E. Chamberlain

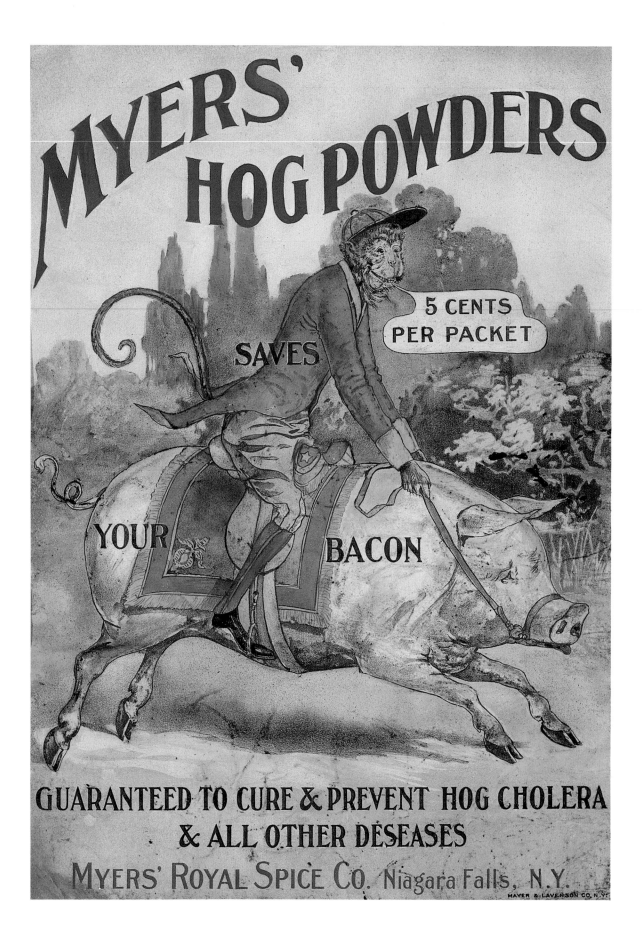

Fairbank's Cherubs. Advertisement for N. K. Fairbank & Co., Lard Fitters, Chicago and St. Louis. Second half of the twentieth century. Lithographic poster, 14¾ × 23½". Library of Congress

The advertisement parodies the cherubs in Raphael's The Sistine Madonna, 1515.

Empire Liniment. Advertisement. Bridgetown, Nova Scotia. 1900. Stone lithograph on paper, 16 × 10". Collection Vernon E. Chamberlain

Opposite:
Myers' Hog Powders. Advertisement for Myers' Royal Spice Co., Niagara Falls, New York. No date. Lithograph on tin. 13¾ × 10". Collection Roi Davis

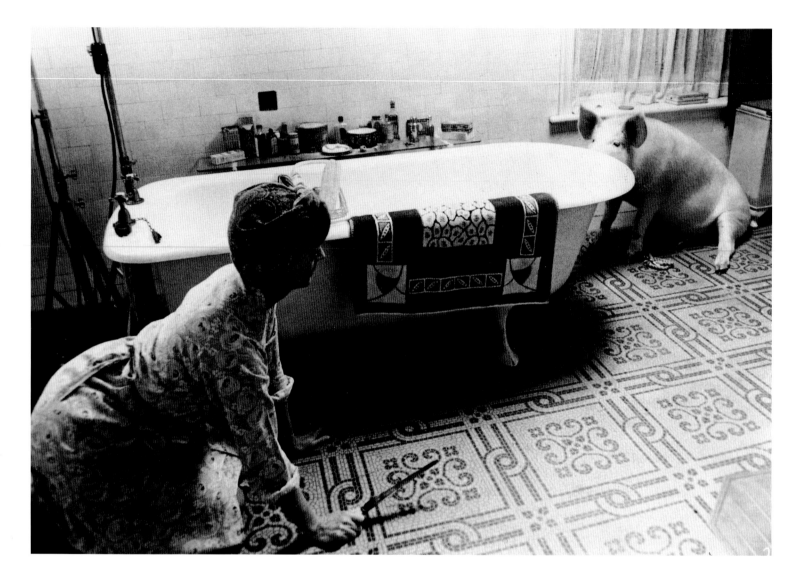

Movie still. Joyce (Maggie Smith) tries to catch the elusive Betty in *A Private Function*. An Island Alive Releasing Presentation of a HandMade Films Production. Copyright 1984 Handmade Films (1984) Partnership

There's More in a Hog than Appears on His Face. Mechanical trade card made by the Gugler Lithograph Co., Milwaukee, Wisconsin, for the Cudahy Packing Co., Omaha, Nebraska, c. 1893. Chromolithograph. Collection Frances Converse Massey

Movie still. Trimalchio's feast from *Fellini's Satyricon*. Released by United Artists/An Alberto Grimaldi Production. 1970

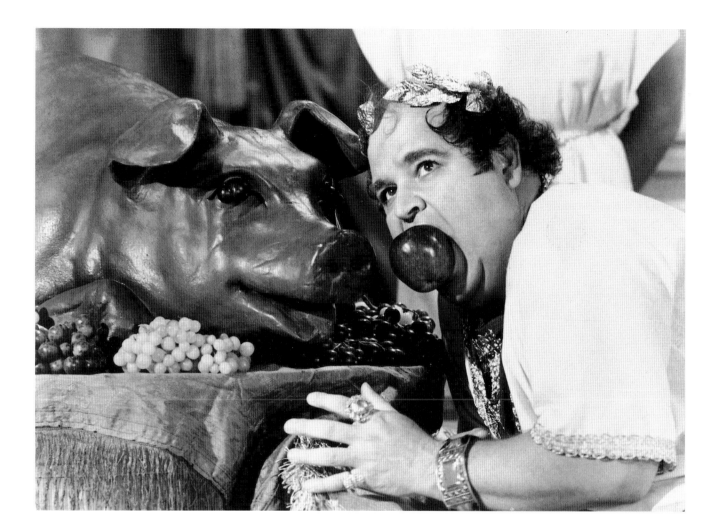

Movie still. Dom DeLuise as Nero in
Mel Brooks's *History of the World Part I.*
Twentieth Century Fox/Brooksfilms
Ltd. 1981

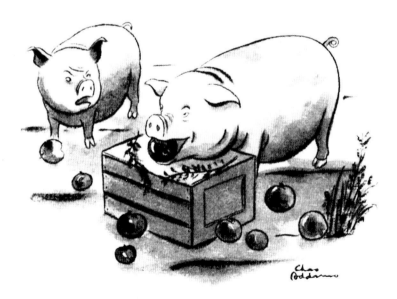

Drawing by Chas. Addams. © 1939,
1967 The New Yorker Magazine, Inc.

"You certainly have a peculiar sense of humor."

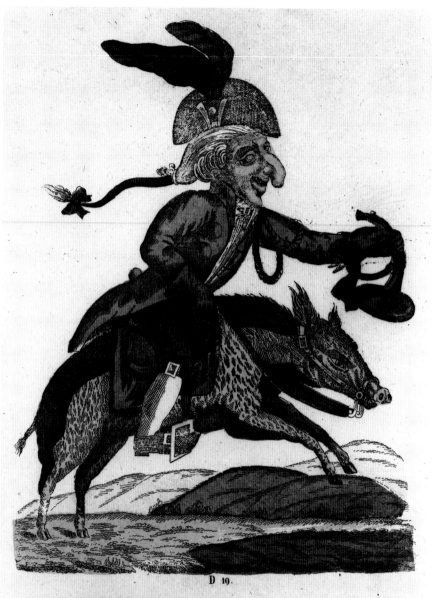

D 10.

Wohin! Wohin die Reise? Nach Schweinfurt

Wohin! Wohin sie Reise? Nach Schweinfurt. German. Eighteenth century. Colored etching. German National Museum, Nuremberg

Drawings and writings that denigrate Jews by pairing them with pigs have a long history in Germany. A ninth-century scholar, Hrabanus, may have been the first to make the connection, knowing that Jews considered pigs anathema. In the thirteenth century, concurrent with a wave of pogroms and expulsions of Jews in the Rhineland and elsewhere, broadsides and church sculptures began to portray Jews being suckled by a sow or wallowing in pig excrement. In his writing, Martin Luther often referred to Jews as pigs or swine, and he believed, erroneously, that the Judensau, as this category of anti-Semitic imagery became known, was based on a translation of a text from the Talmud. The image of a Jew astride a pig was common in anti-Semitic cartoons and political broadsides in the eighteenth and nineteenth centuries.

Hieronymus Bosch (Flemish). Detail from *The Garden of Delights*. c. 1500. Museo del Prado

In Bosch's vision of hell, the pig is a symbol of greed. An abbess in the form of a pig tries to coerce a doomed man into signing his possessions over to the church.

Jeff Koons (American). *Saint John the Baptist*. 1988. Porcelain, 56½ × 30 × 24½". Courtesy Sonnabend Gallery, New York

Jeff Koons's irreverent pairing of a pig with the saint is part of a group of works, including a Christ-like Buster Keaton seated on a donkey and a gilded mirror frame of Jesus with a lamb, made by the artist in the late 1980s. He produced these works to reflect his belief that such images, which formerly evoked religious fervor, have become banal. One critic finds "a holy mischief" in Koon's enterprise, but it has also been described as a "desecration of Art."

117

JEWELS AMONG SWINE.

"The police authorities, that do not enforce the laws against the liquor traffic, that do not suppress gambling or houses of ill repute......distinguished themselves on Saturday by arresting forty-three women, who went on the streets to sing and pray, and marching them to the station-house."—*Cincinnati Gazette.*

Opposite:

Thomas Nast. *Jewels Among Swine*. Political cartoon for *Harper's Weekly*, June 13, 1884. 13⅝ × 9⅛". Library of Congress

The use of pigs as a hostile epithet for policemen can be traced back at least as far as the early nineteenth century in the United States and in England, where it often referred particularly to plainclothesmen. Thomas Nast, the foremost American political cartoonist of the nineteenth century, drew on this well-established association to lampoon some overzealous policemen in Cincinnati. The officers had been criticized in the press for arresting forty-three women who were holding a peaceful demonstration instead of going after real criminals.

October 26, 1912 · **THE COMING NATION** · Price 5 Cents

A JOURNAL OF THINGS DOING AND TO BE DONE

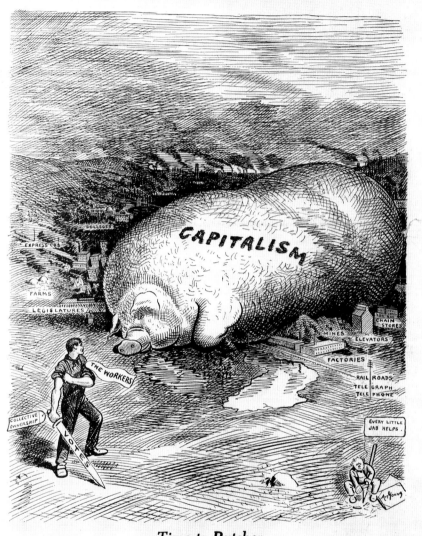

Time to Butcher
For the sake of the beast itself as well as the people

Art Young (American). Political cartoon for *The Coming Nation*, October 26, 1912. General Research Division, The New York Public Library. Astor, Lenox and Tilden Foundations

The Coming Nation was a Socialist weekly published in Kansas. The Left often portrayed capitalists and capitalism as greedy, rapacious, and suffocating—"swinish" in the extreme. Young's drawing indicts capitalism for dominating legislatures, railroads, and the agricultural/industrial complex; in his drawing he urges workers, armed with the vote and the power of collective bargaining, to become heroes by slaying the beast.

En vente chez Grognet Imp. R. des Écoles, 16. Paris.

Dépôt chez Madre, Libraire, R. du Croissant.

Comment Co...quin tu vas manger ton aigle.
Tiens que veux-tu que j'en fasse maintenant.

Enfin, je tiens le record de tous
les crimes du monde.

Je ferai mieux encore
en raison de mon origine.

A. de Ranieri (French). Postcard.
c. 1914. Collection of the authors

The inscription, IN THE
END, I HOLD THE RECORD
FOR THE WORLD'S CRIMES. I WILL
DO BETTER STILL BECAUSE OF MY
TRUE NATURE, *expresses French horror
at the German invasion of 1914.*

Opposite:
Political poster. c. 1870–71. No. 5 in the series
Actualités, sold by Grognet Printers, Paris.
Partly colored lithograph, 13¼ × 10". Courtesy
Westphalian State Museum, Münster, Germany

*According to the caption, a Prussian officer asks his
swinish dinner partner, "You mean to tell me you're
going to eat that eagle?" The pig, who represents the
French bourgeoisie, replies, "What else would you
have me do with it?" This conversation, imagined
during the Franco-Prussian War by a cartoonist
sympathetic to the French Left, accuses the bour-
geoisie of sacrificing the empire of Napoleon III (the
eagle) and collaborating with the enemy in order to
suppress a workers' revolt.*

Postcard celebrating
V-E Day—May 8, 1945—
the Allied victory over the Nazis.
Dutch. Collection of the authors

8 MEI 1945

121

Napoleon. Movie still. "Our leader, comrade Napoleon," wearing a medal he has awarded himself. From *Animal Farm*, Halas & Batchelor, Ltd. 1954

Animal Farm, *the 1954 feature-length animated film, is based on George Orwell's 1946 political fable about what happens when a group of animals revolt against their brutal masters and take over the management of the farm on which they live. In the planning stages of the rebellion, "the work of teaching and organizing the others naturally fell upon the pigs, who were generally recognized as being the cleverest of animals." Among the leaders are Napoleon, "a large rather fierce looking Berkshire boar," his henchman, Squealer, and Snowball, a vivacious and cheery little pig.*

In the beginning of the new social order, "all animals are equal," but before long, "some animals are more equal than others." To explain how Napoleon and his henchmen eventually establish a police state, overcome all their internal opposition, and drive Snowball into exile, Orwell plays on the stereotypical attributes of pigs—their cunning, their alleged greed, and their loutishness.

John Halas and Joy Batchelor, the English animators who were chosen to make the film, began the project by spending a week on a pig farm in Surrey. According to Mr. Halas, they "concentrated on studying pig behavior, especially their reactions to each other, and sketched them at the same time." They observed the tenderness of sows toward their young and the competitiveness and stubborness of the adults. Maurice Denham, the actor who did all the animal voices for the film, profited from his week on the farm by learning just when to punctuate a pig's speech with a sonorous grunt.

Opposite, below left to right:

Preproduction sequential sketches for animation of Napoleon's facial expressions

Preproduction studies for Napoleon

Preproduction studies for Squealer, Napoleon's sidekick

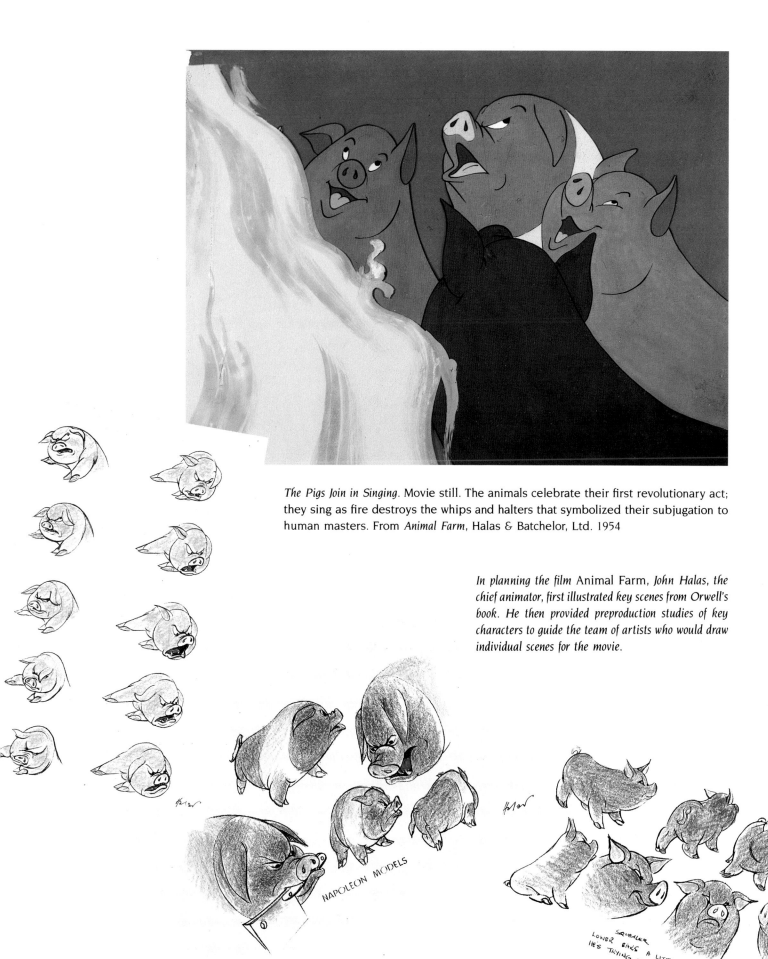

The Pigs Join in Singing. Movie still. The animals celebrate their first revolutionary act; they sing as fire destroys the whips and halters that symbolized their subjugation to human masters. From *Animal Farm*, Halas & Batchelor, Ltd. 1954

In planning the film Animal Farm, John Halas, the chief animator, first illustrated key scenes from Orwell's book. He then provided preproduction studies of key characters to guide the team of artists who would draw individual scenes for the movie.

NAPOLEON MODELS

SQUEALER
LOWER EARS A LITTLE WHEN
HE'S TRYING TO COPY NAP'S
EXPRESSION.

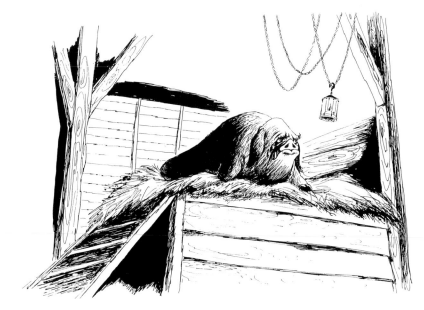

Old Major Addressing Meeting. Preproduction illustration

Old Major is one of the respected leaders of the animal community while it is still under the domination of brutish Farmer Jones. According to Mr. Halas, soon after the film appeared, Herbert Morrison, a Labour MP, asked Winston Churchill why he had allowed himself to be the model for Old Major, the pig, in Animal Farm. *Before Churchill could respond to what he obviously considered an impertinent question, the leader of the House advised Morrison to withdraw such an unfair question to another member. Morrison reluctantly complied. Halas confesses that when he was planning the sequence, he did in fact think of Churchill as the best model for the character but never expected the resemblance to be noticed.*

Squealer and Hens.
Preproduction illustration

Napoleon's Piglets Playing.
Preproduction illustration

Napoleon at the Chopping Block.
Preproduction illustration

Squealer at the Foot of the Ladder. Preproduction illustration

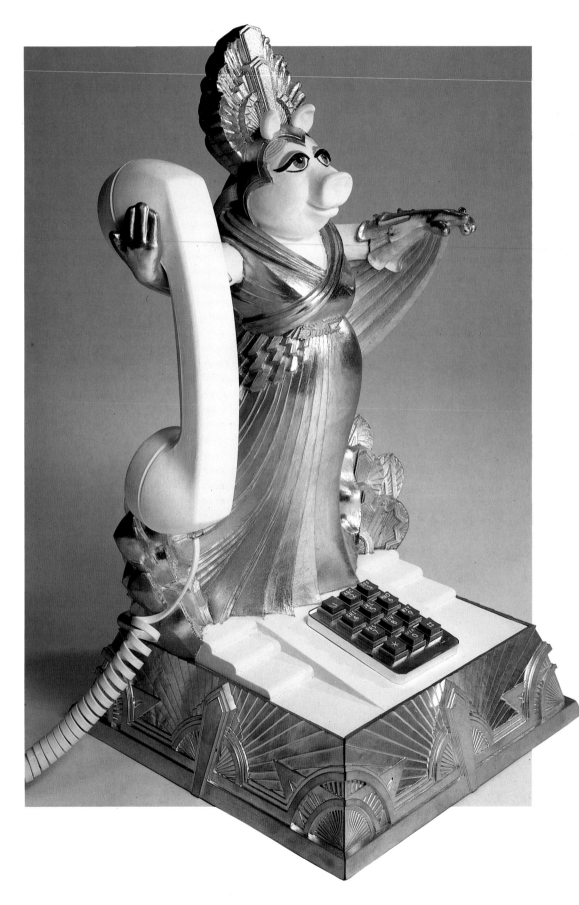

Napoleon's Piglets Playing.
Preproduction illustration

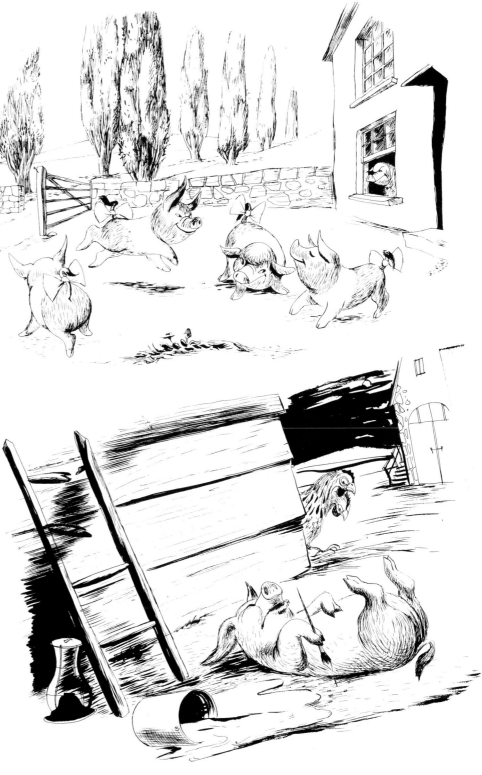

Napoleon at the Chopping Block.
Preproduction illustration

Squealer at the Foot of the Ladder. Preproduction illustration

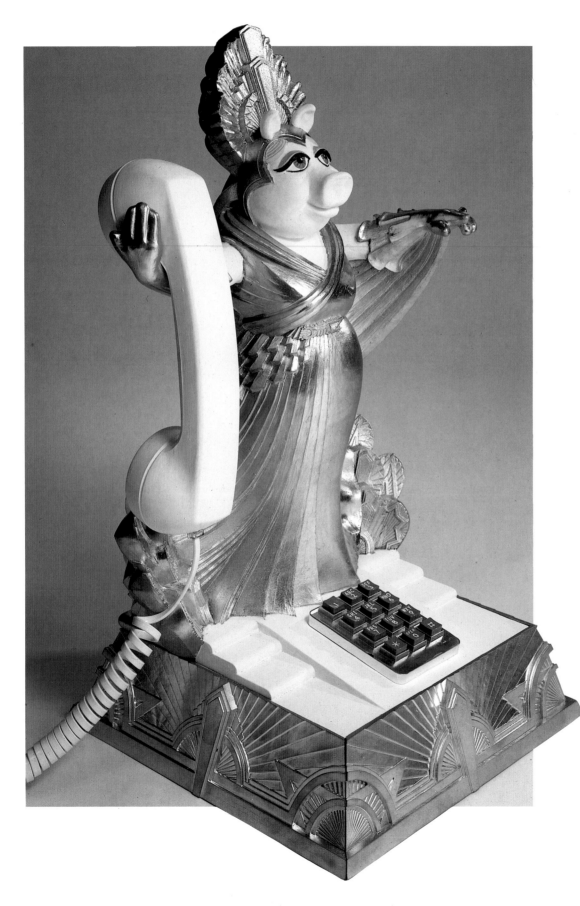

Michael K. Frith. Fan magazine covers created for *The Miss Piggy Cover Girl Fantasy Calendar, 1981*. 1980. Pastel on colored paper, 5½ × 7½″ (top) and 3½ × 5″ (bottom). New York, Harry N. Abrams, Inc. © Henson Associates, Inc., 1980

Opposite:
The Spirit of the Telephone. Design by Michael K. Frith. Modelmakers: Art Buroff, Jim Mahon. A telephone featuring Miss Piggy (unfinished model for an unrealized project): painted plaster, 17″ high. © Henson Associates, Inc., 1983

In the tradition of the show-business clichés she adores, Miss Piggy was plucked from the chorus into stardom. She began her career as backup singer on Jim Henson's Muppet Show. During a rehearsal, under Muppet performer Frank Oz's guiding hand, she began improvising to a sultry song, and a star was born.

By the second season of The Muppet Show, Miss Piggy was a character to be reckoned with. She always wore a gray lounge-singer's dress. Calista Hendrickson, who had been called in to design costumes for another project, recalls, "This Miss Piggy character just cried out to be more flamboyant." Oz was dubious about adding wardrobe, presumably because puppet characters traditionally have only one "look"—like Howdy Doody or Charlie McCarthy. But the program was much more than a puppet show—it had guest stars, production numbers, and a wardrobe budget—and Hendrickson convinced the puppeteer that more costumes would expand the character.

Hendrickson says, "In the beginning, when we started doing clothes for Miss Piggy, we wanted her to be sort of a frump—a fat person who didn't dress right. But she had aspirations for a Hollywood career. One of the earliest costumes we did for her was a backstage dressing gown with ostrich boa trim. Piggy's first really big production number was a Carmen Miranda—type thing—'Quanta La Gusta.' She loved all the great Hollywood glamour queens, and she wore her very own version of their styles."

As her fame increased, Miss Piggy often downplayed her origins; her creator, Frank Oz, had to remind her gently of her barnyard roots. Perhaps "back on the farm" was where Piggy gained the resourcefulness and stubborn determination that enabled her to become a superstar. The Muppet Show ran for five seasons; she and Kermit starred in three feature films; she wrote a best-selling book of advice on beauty and fashion; she published a lavish volume on her inimitable art collection (The Kermitage); and she posed for five breathtaking calendars.

Michael Frith, the executive vice-president and creative director of Henson Productions, who helped guide Miss Piggy's career, attributes her success to her strong self-image: "She's a natural leader. She can survive defeat; she knows when to go for it. She's capable of anything. If she thought the job was worth it, she could even be president of the United States."

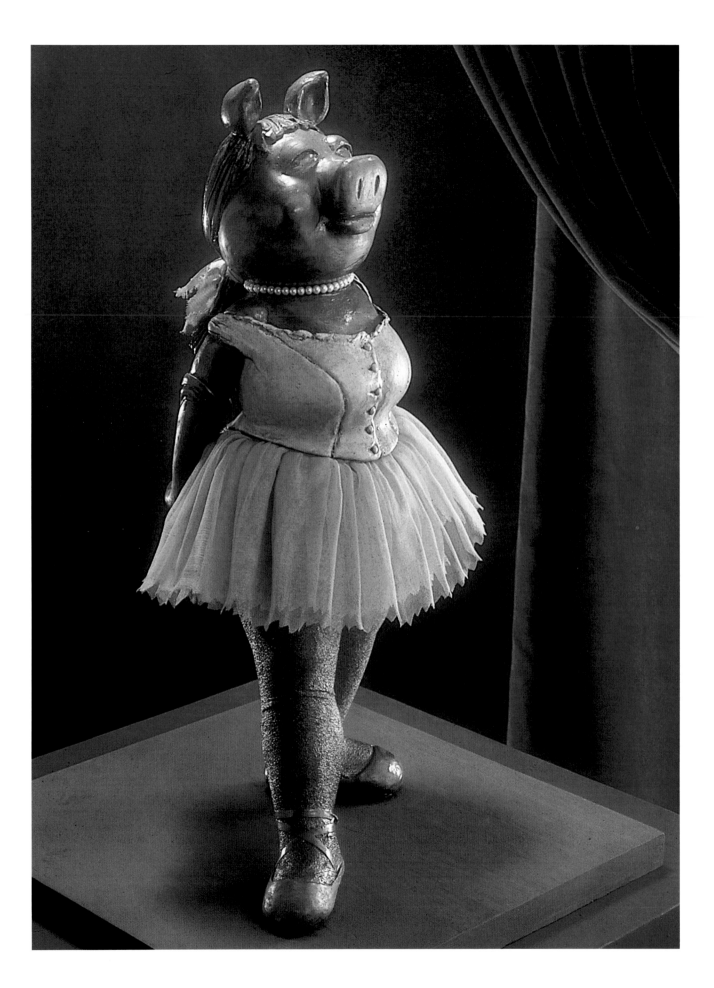

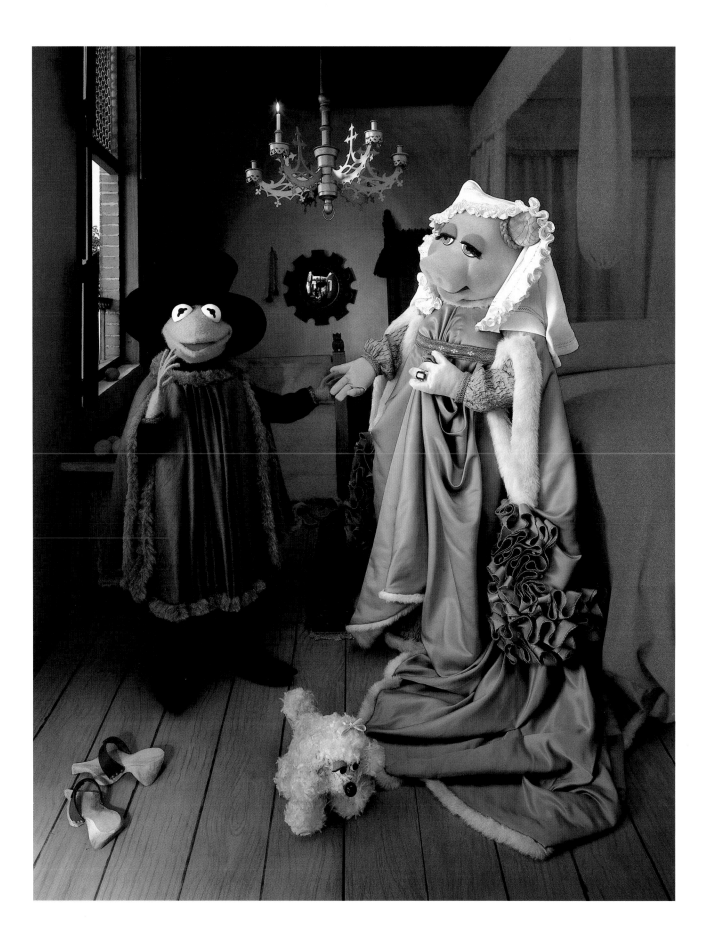

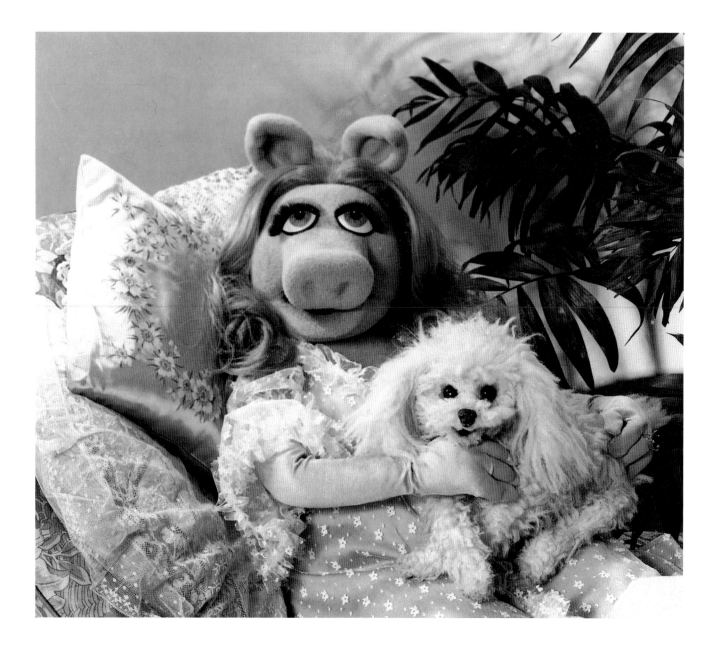

Frontispiece from *Miss Piggy's Guide to Life*, by Miss Piggy, as told to Henry Beard. New York, Muppet Press/Alfred A. Knopf. © Henson Associates, Inc., 1981

Opposite:
Pig of the Year. From *The Miss Piggy Cover Girl Fantasy Calendar, 1981*. New York, Harry N. Abrams, Inc. © Henson Associates, Inc., 1980. TIME cover format and trademarks used with permission of Time Inc. Magazine Company

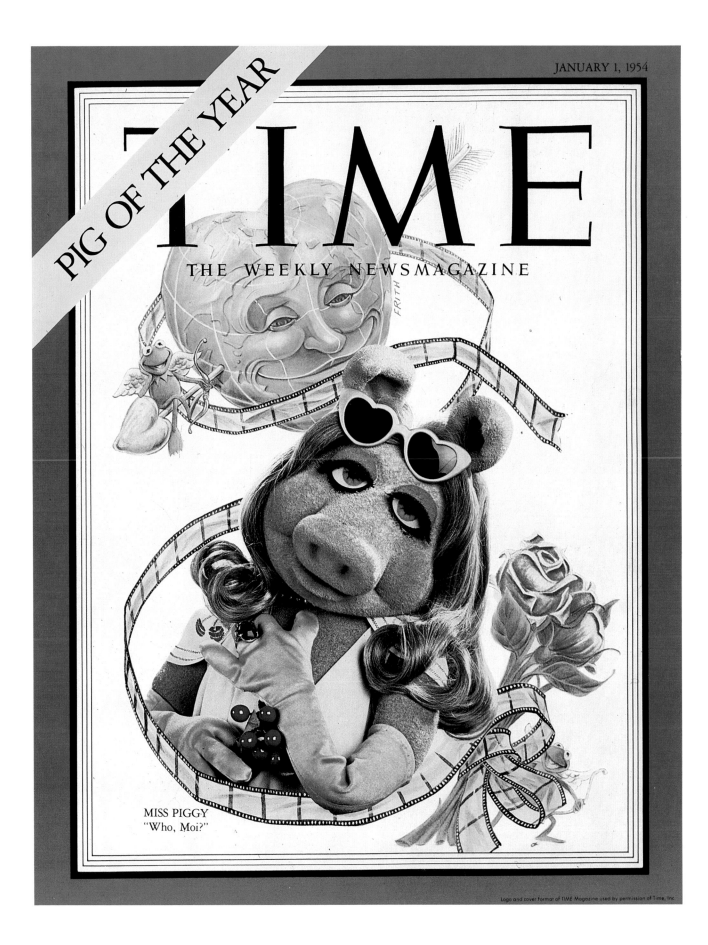

JANUARY 1, 1954

PIG OF THE YEAR

TIME

THE WEEKLY NEWSMAGAZINE

MISS PIGGY
"Who, Moi?"

SELECTED BIBLIOGRAPHY

Amory, Cleveland. *The Proper Bostonians*. New York: E. P. Dutton, 1947.

Animals in Art. Edited by Jessica Rawson. London: British Museum, 1977.

Baring-Gould, Reverend S. *The Lives of the Saints*. Edinburgh: J. Grant, 1914.

Beresford, John. "Reflections on Bacon." In *Storm and Peace*. London: Cobden and Sanderson, 1936.

Berger, John. "Why Look at Animals." In *About Looking*. New York: Pantheon, 1980.

Bewick, Thomas. *A General History of Quadrupeds*. Newcastle upon Tyne, England: S. Hodgson, R. Beilby, and T. Bewick, 1790.

Bonera, Franco. *Pigs: Art, Legend, History*. Boston: Bulfinch Press, 1991.

The Book of Days, A Miscellany of Popular Antiquities. Edited by R. Chambers. Vol. 1. Detroit: Gale Research Corp., 1967.

Brasch, Walter. *Cartoon Monickers*. Bowling Green, Ky.: Bowling Green Popular Press, 1983.

British Sporting and Animal Painting, 1655–1867. Compiled by J. Egerton, The Paul Mellon Collection, The Tate Gallery for the Yale Center for British Art, 1978.

British Sporting and Animal Prints, 1658–1874. Compiled by Dudley Snelgrove, The Paul Mellon Collection, The Tate Gallery for the Yale Center for British Art, 1981.

Chesterton, G. K. "The Uses of Diversity." In *The Collected Works of G. K. Chesterton*. San Francisco: Ignatius Press, nd.

Clark, Kenneth. *Animals and Man*. London: Thames and Hudson, 1977.

Dictionary of American Slang. Compiled by Harold Wentworth and Stuart Berg Flexner. New York: Thomas Y. Crowell, 1967.

Dictionary of National Biography. Vol. 13. London: Oxford University Press, 1968.

Dodgson, Charles (pseud. Lewis Carroll). *Alice's Adventures in Wonderland*. Illustrated by Sir John Tenniel. London: Macmillan, 1866.

English Caricature 1620 to the Present: Caricaturists and Satirists. London: Victoria and Albert Museum, 1984.

Evans, E. P. *Animal Symbolism in Ecclesiastical Architecture*. London: Heineman, 1896.

Friedwald, Will, and Jerry Beck. *The Warner Bros. Cartoons*. Metuchen, N.J.: Scarecrow Press, 1981.

Gilbey, Sir Walter. *Animal Painters of England*. Vol. 2. London: Vinton and Co., 1900.

Grzimek's Animal Life Encyclopaedia. Vol. 13, edited by Dr. Bernhard Grzimek. New York: Van Nostrand Reinhold, 1972.

Harris, Marvin. *Cows, Pigs, Warriors, and Witches: The Riddles of Culture*. New York: Random House, 1974.

Hedgepeth, William. *The Hog Book*. New York: Doubleday, 1978.

Kaftal, George. *Saints in Italian Art*. Florence: Casa Editrice le Lettere, 1986.

Klingender, Francis. *Animals in Art and Thought to the End of the Middle Ages*. Cambridge: MIT Press, 1971.

Miss Piggy's Guide to Life. As told to Henry Beard. New York: Muppet Press/Alfred A. Knopf, 1981.

Morison, Samuel Eliot. *Three Centuries of Harvard: 1636–1936*. Cambridge: Harvard University Press, 1936.

Narrative of the Career of Hernando de Soto, As Told by a Knight of Elvas. Original edition 1557. Revised edition edited by Edward Bourne. New York: A. S. Barnes, 1904.

Orwell, George. *Animal Farm*. New York: New American Library, Harcourt Brace Jovanovich, 1946.

Pig Parade. London: Elmtree Books/Hamish Hamilton, 1985.

Pound, Glen. "Phonological Distortion in Spoken Secret Languages; A Consideration of Its Nature and Use." Ph.D. dissertation, Indiana University, 1964.

Read, Allen Walker. "Otesnay Onnay Igpay Atinlay: The History and Analysis of Pig Latin." Paper presented at Modern Language Association meetings, New York, 1944.

Schneider, Steve. *That's All Folks: The Art of Warner Bros. Animation*. New York: Henry Holt, 1988.

Scott, Jack Denton. *The Book of the Pig*. New York: G. P. Putnam, 1981.

Sedgwick, John. "Brotherhood of the Pig." *GQ* (November 1988): 304–7.

Sedgwick, John. "The Porcellian at 200." *Harvard Magazine* (March–April 1991): 59–62.

Shachar, Isaiah. *The Judensau: A Medieval Anti-Jewish Motif and Its History*. London: The Warburg Institute, University of London, 1974.

Sillar, F. C., and R. M. Meyler. *The Symbolic Pig*. London: Oliver and Boyd, 1961.

Towne, Charles W., and Edward N. Wentworth. *Pigs from Cave to Corn Belt*. Norman: University of Oklahoma Press, 1950.

White, E. B. "Death of a Pig." In *Essays of E. B. White*. New York: Harper & Row, 1977.

Winfrey, Laurie Platt. *Pig Appeal*. New York: Walker, 1982.

Wolpert, Stanley. *A New History of India*. New York: Oxford University Press, 1982.

INDEX

ACKNOWLEDGMENTS

We are indebted to the reference librarians and curators of various collections of the New York Public Library. The National Pork Producers Council was also an excellent source. We are grateful for the generous help given us by Hugh Nissenson; Frances Converse Massey; Gillian Kyles; Calista Hendrickson; Bill and Cordelia Hubbard; John Halas; and Michael K. Frith, Jane Leventhal, and Jennie Lupinacci of Jim Henson Productions.

We thank the following people for information and suggestions: Professor Allen Walker Read, John Sedgwick, Marilyn Minden, Kiyoko Hancock, Elisabeth Biondi, Elaine Block, Andreas Brown, Mrs. Thurmond Campbell, Katharina Farber, Eliot Hawkins, Jane Jampolis, Judd Kahn, Bettyann Kevles, Carole Kismaric, Susan Kismaric, Barbara Maysles Kramer, George Marlin, Charles Mikolaycak, Millie and Mario Materassi, Barbara Richert, Anne Rogin, Dr. Wilfried Schouwink, Calvin Trillin, Lou Valentino, and Laurie Winfrey.

We also thank those who led us to wonderful objects and images: Michael Cart, Marcia Carter, Vernon E. Chamberlain, Roi Davis, Ralph Esmerian, Marilyn Karmason and Joan Stacke, Davis Mather, Marilee Boyd Meyer, Steve Schneider, Lori Stein, Peter Schaffer and Rose Casella of A La Vieille Russie, Betty Muirden of The Yale Center for British Art, Adelaide Bennett at the Index of Christian Art at Princeton University, Pauline Mitchell of the Shelburne Museum, Howell Perkins of the Virginia Museum of Art, Judith Smith of the Museum of International Folk Art, Eric Holck at Warner Bros., Liz Allsopp of the Rothamsted Experimental Station, Donald Hutslar of the Ohio Historical Society, Jacqueline Dugas of the Huntington Art Collections, Maureen Twohig of the Cahoon Museum of American Art, Christopher Bibby of the Rutland Gallery, Stephen Joseph at Iona Antiques, and Ronnie Brenne at the Bettmann Archive.

We are grateful to Paul Gottlieb, Harriet Whelchel, and Carol Robson of Harry N. Abrams, Inc., for their professional expertise and enthusiastic support.

PHOTOGRAPH CREDITS

Art Resource: 69, 104–5, 106. Barbey, Bruno/Magnum Photos, Inc.: 75. Barrett, John E.: 130, 131, 132. Beaurline, Philip: 1, 7, 17 top, 27, 36, 37 top and middle, 43 top, 48, 49, 53, 54, 55, 56, 59 bottom, 88 bottom right, 113. The Bettmann Archive: 30, 44 top, 72, 83 top, 85, 103. Brack, Dennis: 42–43, 86 bottom. Burris, Ken: 46 bottom, 47 bottom, 134. Clark, Blair: 71 bottom. The Granger Collection: 86 top. James, Jacqueline: 31. Monteaux, Michel: 71 top. Parnell, John: 32 bottom, 52 bottom, 68 bottom, 88 top left, 97, 121 middle, 126. Photofest: 112, 114, 115 top. Stock, Dennis/Magnum Photos, Inc.: 84. Zindman/Fremont, Inc.: 45, 81.